Contemporary American Luminism

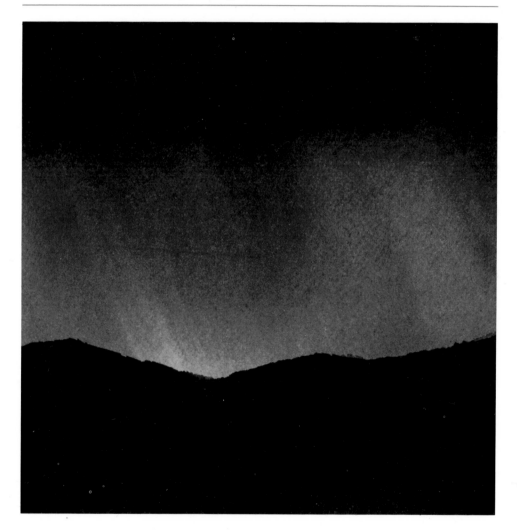

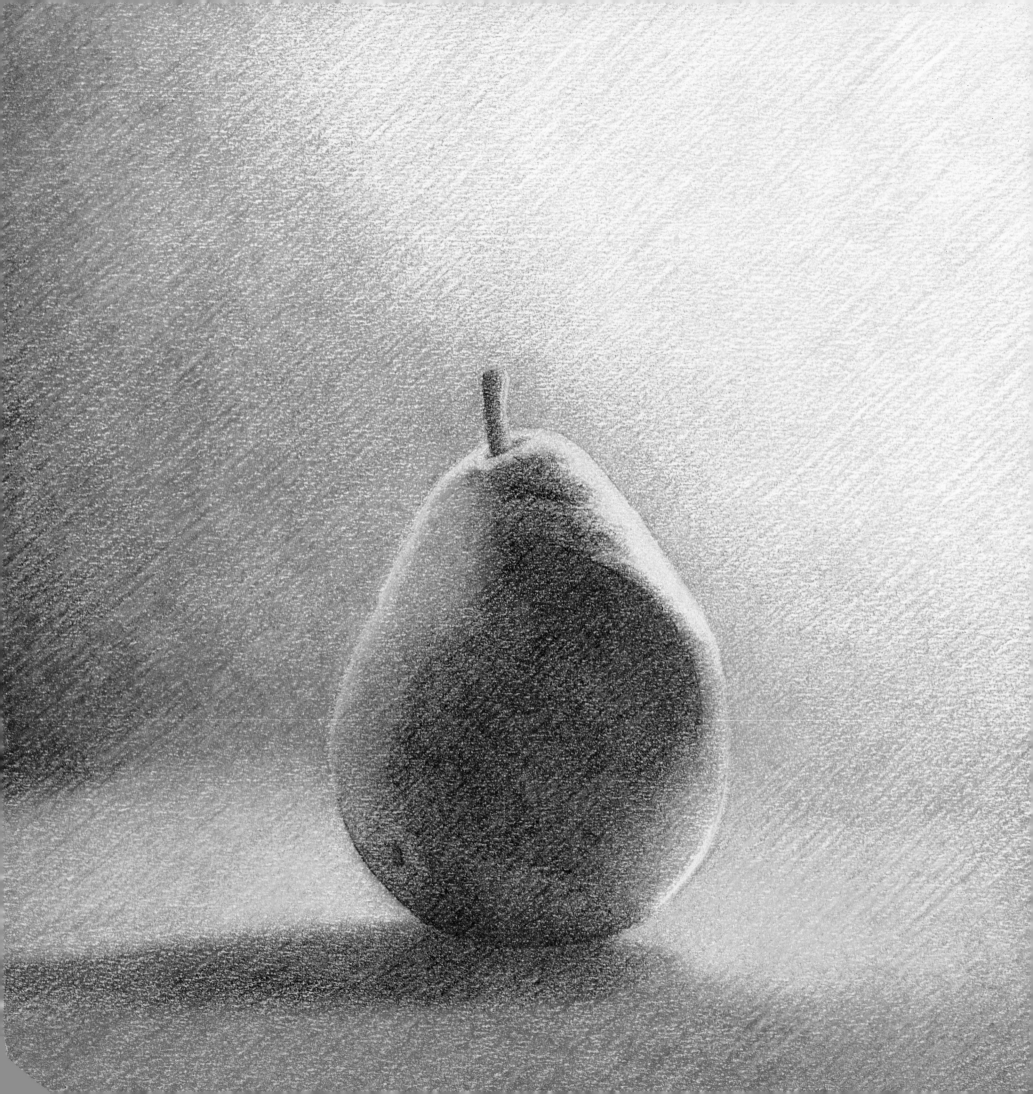

Sources of Light

Contemporary American Luminism

Martha Alf

Roger Brown

April Gornik

Alfred Leslie

Norman Lundin

Ed Paschke

Essay by Harvey West **Biographies by Chris Bruce**

 Henry Art Gallery
University of Washington, Seattle

Prepared in conjunction with the exhibition
"Sources of Light: Contemporary American
Luminism," held at the Henry Art Gallery,
University of Washington, Seattle,
April 3-May 26, 1985.

Library of Congress
Catalog Card Number: 85-60256
ISBN: 0-935558-13-6

This catalogue has been funded in full by the
Henry Gallery Association.

Edited by Joseph N. Newland

Designed by Douglas Wadden

Front Cover, p. 1, p. 2:
Details of Alfred Leslie, *Approaching the Grand
Canyon,* 1977-81 (see p. 25), and Martha Alf, *Pear No. 1 (for
Andy Wilf),* 1982 (see page 18).

Back Cover: Roger Brown, *Rain and Shine,* 1978 (see page
72.)

Henry Art Gallery
University of Washington
Seattle, Washington 98195

Foreword and Acknowledgments

The Henry Art Gallery, the art museum of the University of Washington, organizes and presents to the campus and community exhibitions of contemporary and historical art in all media. The Henry Art Gallery and Henry Gallery Association also regularly sponsor art lectures and symposia, and since 1979 have copublished a number of art books and exhibition catalogues. Their partnership has enabled publishing to become a major part of the Gallery's program on American art.

On March 11, 1926, Horace C. Henry gave to the University his collection of paintings and sufficient funds for a building to house it. When the Horace C. Henry Art Gallery opened on February 10, 1927, it was the first public art museum in the state. Our present study of American art history is in no small part due to Mr. Henry's interest in the art of this country and his gift of a largely American collection. Our exhibits of historical art are balanced by a similar commitment to contemporary American art.

Although the Gallery has been used primarily for special exhibits since 1928, the University's art museum maintains an expanding collection presently numbering approximately 16,500 objects. In addition to the American and European paintings donated by Mr. Henry, important gifts of paintings have been made by Brian T. Callahan; photographs by R. Joseph and Elaine R. Monsen; prints and drawings by Dorothy Stimson Bullitt, Edna Benson, Mr. and Mrs. Ray Vellutini, Wesley Wehr and an anonymous benefactor; and ceramics by Mr. and Mrs. Robert Sperry and Elizabeth Bayley Willis. By far the largest part of the collection is the 14,500 piece textile and Western dress collection assembled since 1920 by University faculty in the School of Home Economics and the School of Drama and transferred to the Gallery in 1982. There are excellent representations of historic Western costumes and of ethnic textiles from India, East Asia and South America, including pre-Columbian fragments. Over the years important textile collections were donated by Virginia and Prentice Bloedel, Elizabeth Bayley Willis, Mr. and Mrs. Eugene Garbaty, Harriet Tidball, Mrs. Russell J. Matthias, Helen Stager Poulsen, and Mr. and Mrs. Thomas Drumheller. Areas that are earmarked for growth in the 1980s are the works on paper and textile collections.

Works on paper are housed in the Eleanor Henry Reed Gallery, built with funds given in 1980 by William G. Reed, Sr., in honor of his wife, Eleanor Henry Reed, the granddaughter of Horace C. Henry. This beautifully appointed room is used for the storage and exhibition of the Gallery's growing collection of paintings on paper, prints, drawings and photographs, including the Stimson-Bullitt Collection of European Prints, the Margaret T. Callahan Memorial Collection and the Monsen Study Collection of Photography.

Sources of Light: Contemporary American Luminism has been published as a companion to the Gallery's spring 1985 exhibition of 91 luminist paintings and drawings by six exceptional artists: Martha Alf, San Diego; Roger Brown, New Buffalo, Michigan/Chicago; April Gornik, New York City; Alfred Leslie, South Amherst/New York City; Norman Lundin, Seattle; and Ed Paschke, Chicago. All represent the play of light—ranging from the soft natural light in Alf's drawings to the prismatic video blast of Paschke's paintings—and together compose one band in the spectrum of contemporary luminism. The creative work of these artists, the loans from 52 collectors, the artists and dealers, the photograpy that enabled us to reproduce the works, Chris Bruce's biographical sketches of the artists, Joseph N. Newland's catalogue formating and editing, Douglas Wadden's design, the printing by Nissha, Ltd., and, of course, the funds from patrons who made all this possible, all represent a concerted effort by an international team.

It is our collective belief at the Henry that we must present the opportunity to look at art as well as read about and discuss it and the artists. Since 1979, we have become an active publisher. The Gallery and patrons have

believed from the beginning that excellence of both form (design/production) and content (format/text/illustrations) are essential. Exhibition-related books and catalogues give the Gallery the means to document and embellish the curatorial purpose of each exhibit. A loan exhibition necessarily has a limited time span, and a publication functions not only as a record of it but also goes far beyond the physical confines, in time and space, of an exhibition at the Henry. Even some of the artists celebrated by this catalogue were unable to visit the exhibit and see their work in this particular context. Therefore this catalogue has been crafted as carefully as the exhibition in order to best present in printed form the art, the artists and the idea.

Our publications also give us an opportunity to identify those individuals who have given generously to help bring about the success of a project. One of the privileges we have in our work is the opportunity to associate with such exceptionally talented people: the artists, our museum colleagues, dedicated collectors, dealers and, of course, the people and organizations who give of their time and money. To walk into a gallery filled with great art works, at about 11:00 A.M. when the daylight is just right, is pure visual magic. That would not be possible at the Henry Art Gallery or any other museum without the work—much of it "invisible"—of a great number of people. We feel fortunate to have received their support, it is deeply appreciated. Thank you all!

The Henry Art Gallery receives the support of Dr. Ernest M. Henley, the Dean of the University's College of Arts and Sciences, and Dr. David McCracken, Associate Dean for the Arts and Humanities. A unique and enormously productive partnership has been established between the University and the Henry Art Gallery Association. Today's Association—its officers, trustees, patrons and a growing membership from the campus and the community at large, led by its Director, Mrs. John E. Z. Caner, and President of the Board of Trustees, H. Raymond Cairncross—is the major reason for the Gallery's recent programming growth and the vitality and scale of its current activities. We have enjoyed our past and present successes and have set challenging goals for tomorrow, and for this I am grateful.

Here, first and foremost, our gratitude is due to the six artists in this exhibition. Behind each of them are dealers and collectors who assisted in locating the art works most appropriate for this particular exhibition. Special thanks go to the dealers for help with loans, photographs and endless details. Joni Gordon of Newspace Gallery, who represents Martha Alf, was especially helpful in the early planning stages. Roger Brown and Ed Paschke are represented in New York and Chicago by Phyllis Kind Gallery; special thanks go to Phyllis Kind, to Carol Celentano in New York and to William H. Bengtson in Chicago for all of their efforts on our behalf. Richard Bellamy of Oil & Steel Gallery was the moving force behind Alfred Leslie's inclusion, and Louis Zona of the Butler Institute of American Art was instrumental in helping us secure the works, which have been travelling under the Butler's auspices. Edward Thorp and Rebecca Lax of Edward Thorp Gallery assisted with loans of April Gornik's work. Norman Lundin is represented in Seattle by a dear friend, Francine Seders; in Los Angeles by Ed Lau at Space Gallery; by Allport Associates in San Francisco, where we worked with Ardis Allport and Patty Spiegal; and in Dallas, Anita Middleton and Lisa Hamm of Adams/Middleton were most cooperative as well. To each of the lenders, who are listed elsewhere, goes our very special gratitude. Their support, enthusiasm and willingness to part with their works for the duration of the exhibition have enabled us to assemble a representation of each artist of which we all can be proud. Curator Chris Bruce and I have worked closely and continuously with most of them, and appreciate their invaluable assistance. Vital contributions to the catalogue were made by Linda Castle, Linda Dean and Patricia A. Tobin who typed the many manuscript drafts; editorial assistants Hattie Gault Freeman and Elaine Schmidt; and the copy photographers.

My final expression of appreciation goes to PONCHO, an organization of individuals who have no equal in our community. For the past 23 years, they have given of their time, imagination and resources to stage a gala benefit auction each spring, the proceeds of which are given to civic, cultural and charitable organizations in the greater Seattle area. PONCHO has been one of the major supporters of the Henry Gallery Association publication fund, and gave the majority of funds needed for this book; we are indeed in their debt.

Harvey West

Director
The Henry Art Gallery

Lenders to the Exhibition

Jean and Dennis Albano

Martha Alf

Allport Associates Gallery, San Francisco

Stephen S. Alpert Family Trust

Mr. and Mrs. Lawrence I. Aronson

Daisy and Daniel Belin

Richard Bellamy

R. K. Benites

John Berggruen Gallery, San Francisco

Roger Brown

Richard D. and Jane Burns

Laura Carpenter

Gregory and Lourine Clark

Continental Illinois National Bank and Trust
Company of Chicago

Corson/Davis Collection

Frank M. Finck, M.D.

Arthur and Carol Goldberg

Joni and Monte Gordon

Irving B. and Joan W. Harris

Alan S. Hergott

Archer M. Huntington Art Gallery, University
of Texas at Austin

Karl K. Ichida

Frits de Knegt

Susan Leigh

Alfred Leslie

Norman Lundin

Dr. Alvin Martin

Frederick and Jan Mayer

Robin Wright Moll

Newspace Gallery, Los Angeles

Oil & Steel Gallery, New York

O'Melveny and Myers

Ed and Nancy Paschke

Riddell, Williams, Bullitt & Walkinshaw

William and Christine Robb

Helen R. Runnells

Mr. and Mrs. Barry Sanders

Francine Seders Gallery, Seattle

Mr. and Mrs. Edward Byron Smith, Jr.

The Southland Corporation, Dallas

Space Gallery, Los Angeles

Mr. and Mrs. Alexander C. Speyer III

Jane Timkin

Mr. and Mrs. Bagley Wright

Private Collections

Table of Contents

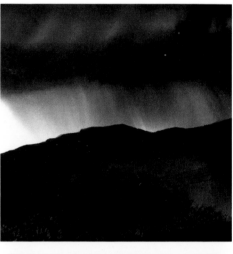

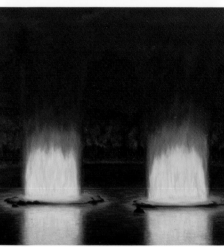

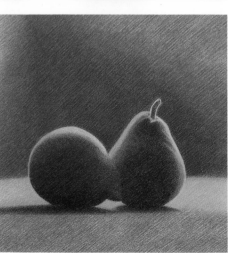

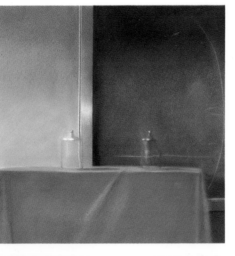

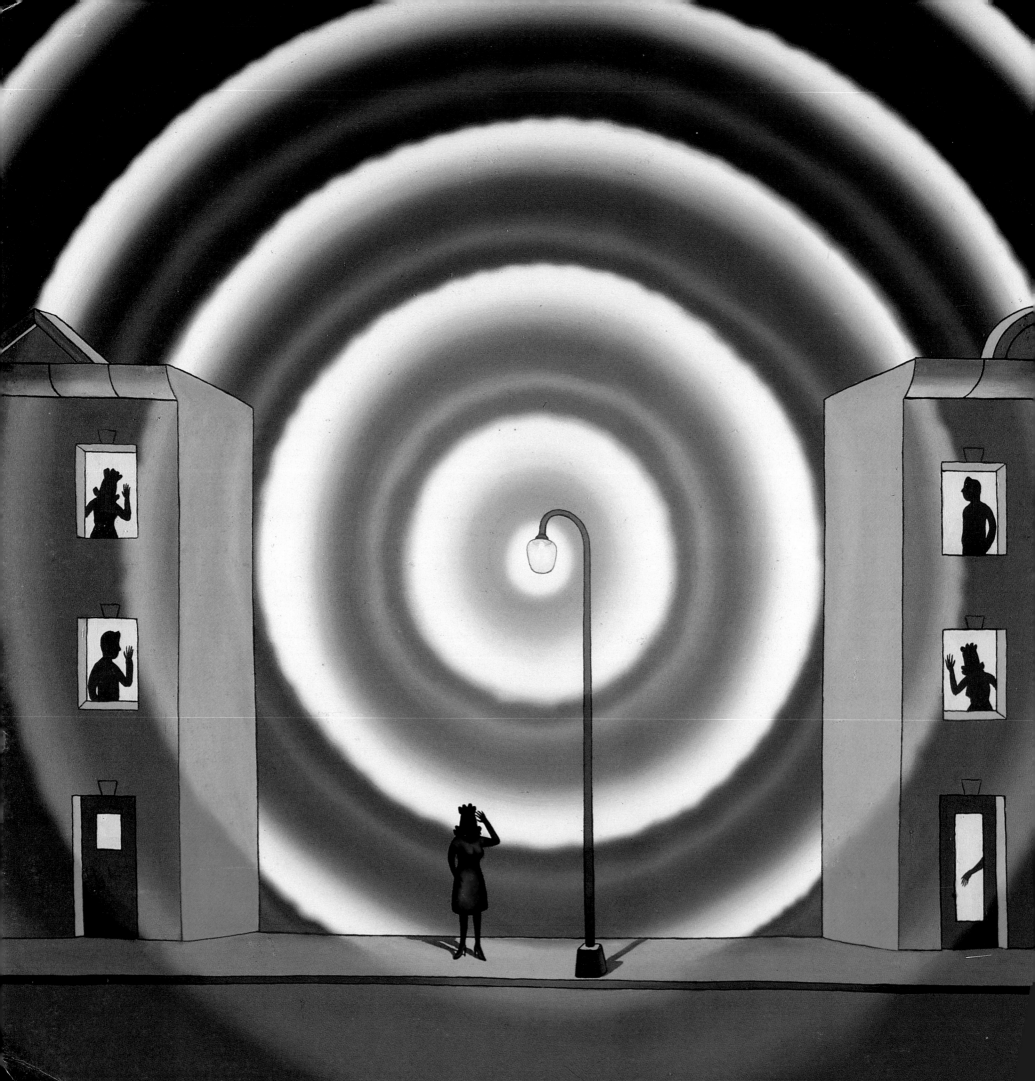

The Anatomy of a Project

Harvey West

The Idea at the Henry

The origin of every special exhibition at the Henry Art Gallery is a question, in this case, What is contemporary American luminism? I would like to place my discussion of the paintings and drawings of the six artists included here in the context of the Gallery's larger program, and to take this opportunity to share with you the inner workings of the Gallery as a programming university art museum.

Our focus on organizing special exhibitions using national resources is a clear indication of the Gallery's purpose at this point in its 58-year history. Every active art museum organizationally cycles between four periods, though not necessarily in the following order: growth and use of permanent collection, building or expanding facilities, financial stabilization and special public programming. Typically a museum must choose to focus on one or two of these, and it is rare that three or all four are undertaken during any one period.

In 1926 Horace C. Henry accomplished the first phase of the building and collecting cycles for the Henry Art Gallery.[1] Since 1928—when the Henry Collection was first taken down—the Gallery has emphasized special exhibitions rather than the installation of the collection.[2] In 1979 the Gallery began an active program of organizing national loan exhibitions and publishing to lay the foundations for undertaking the next phase: construction of additional facilities—enabling the permanent installation of a large selection of the Henry Collection in the Henry Art Gallery—and growth of the collection.[3]

To examine the nature of the visual arts and to bring together the necessary forms of communication to challenge our collective assumptions about them, the Gallery starts with a "curatorial question" and ends with a "museum answer," which includes visual (exhibition), written (publication) and spoken (lecture/symposium) components. This inquiry into today's luminism evolved from my interest in and appreciation of 19th-century American painting. The most recent major statement on historical American luminism was the National Gallery of Art's *American Light: The Luminist Movement, 1850-1875* (1980), and recently there have been a number of other exhibitions and publications on light in American painting, whether luminist, tonalist or impressionist.[4]

Shifting the study of artists' light to the present began with a spring 1984 telephone conversation with Joni Gordon, director of Newspace Gallery in Los Angeles, who asked me to consider showing a Martha Alf retrospective exhibition.[5] Since the Henry had just organized and shown a William Merritt Chase retrospective, we were not interested in another one-person exhibition at that time.[6] During our conversation, Joni characterized Alf as "a luminist," and when I heard her apply this term to a living artist, the seed for this group exhibition was planted. Shortly thereafter I telephoned Martha for her reaction to being included in an exhibition and publication on luminism. Her reaction was very positive. Within a month, based on an insightful comment by Joni Gordon, a curatorial examination of contemporary luminism was underway.

At approximately the same time I was looking for formal similarities between 19th- and 20th-century painting, which most critics and art historians overlook in favor of elucidating the theoretical differences between traditionalists and modernists. Despite the seemingly uncompromising pronouncements of abstractionists, there are indeed connections between contemporary art and that of the past. I never have been convinced that the late 19th-century artists marked the end of an American painting tradition—I see many commonalities between their art and much contemporary painting. Formal and temperamental similarities are too apparent to be ignored. Consequently, when looking for connecting tissue, I have accepted certain generational and philosophical differences and have attempted to look beneath them for the basic concerns of picture-making: space, color, line, scale and light. Light is the bond between the artists included here and between them and many artists who painted over 100 years ago. Subsequent to this study of contemporary luminism, the Gallery will undertake an exhibition that includes both 19th- and 20th-century luminist artists.

Detail of
Roger Brown
Streetlight. 1983
Oil on canvas
48 x 72 in
Collection of Gregory and Lourine Clark

A Partnership at the Henry

The Henry Art Gallery and Henry Gallery Association formed an important partnership in 1967 with the common purpose of the organization of educational programs for the University and community.[7] This town and gown collaboration was almost predestined: the Gallery was deliberately placed on the edge of the campus to give easy access to both the University and the public. In the past six years both the Gallery and the Association have striven to make their management more effective and have focused on special programming and financial stabilization. Thanks to the Association's efforts these are well under way.

Since 1978, the Gallery's programming emphasis has been on *American* art history and the idea of the *Modern* in American art. Historical and contemporary art exhibitions are presented in alternating series, each of which extends over a twelve- to eighteen-month period. These series facilitate the development and presentation of curatorial ideas to best advantage. The educational process is accumulative, and we have found that a group of related programs has a greater effect than isolated events. Moreover, some subjects are too large for a single show. For example, in 1980-82 a survey of art in Washington State was mounted in two 12-month series, one of nine exhibits including 169 Washington artists that was followed by 10 exhibitions of art in Washington collections. While not exhaustive, they far surpassed what could be included in a single exhibition devoted to each topic. "Sources of Light: Contemporary American Luminism" is part of an 18-month series that examines issues in contemporary American art.

Two independent partnerships are necessary for organizing an exhibition and related programs. The University and the Association give the Gallery the ways and means to ask a question, such as this one on luminism. The answer is supplied by the artists and their support system. In the case of contemporary projects, the artists are assisted by their dealers and collectors of their work. In the case of an art historical issue, the answer is shaped by scholars, again with the assistance of collectors and dealers. Until the exhibition actually opens in Seattle, the discussion remains within this network of individuals and their support personnel (shippers, photographers, researchers—the list goes on and on).

It is a true privilege to be able to exhibit unique art objects from public and private collections. The willingness to share such objects with the Gallery and our visitors is the basis for our entire special program: without it we don't have one. It is astonishing that modern art museums have evolved such sophisticated borrowing and lending practices. Although I have been directly involved with this process for a number of years, I am still amazed by the deep generosity of the patrons of the arts and collectors we work with so often.

The money required to support the luminism exhibition and catalogue (and all special programs at the Gallery) comes from three sources: the University, the Association's patrons, and those who see the exhibitions and purchase the books. Project expenses are charged against these, typically as follows: the University pays for Gallery staff salaries, overhead and building maintenance; the Association underwrites art transport, publishing and graphics; admission fees cover security and exhibition insurance; and sales support publishing and graphics. It has been our experience that approximately 20 percent of the total cost of an exhibition of contemporary art is supported by Gallery visitors, and the national book-buying community will support about 50 percent of the direct catalogue costs over a two-year period. The total cost of the "Sources of Light" exhibition was approximately $75,000, and the direct production costs of the catalogue were $25,000. I share this budgetary information with you because it seems to me important that you have a sense of the real costs of a museum's answer to a curatorial question.

The art museum plays a unique role within the American art community. It can initiate the most comprehensive study of art possible, simply because it begins with actual art objects. A museum can bring together a unique constellation of art works; publish illustrated documentary texts; invite artists, scholars, critics and other expert lecturers—all for the participants' increased appreciation and understanding of the art and issues involved. As I have said on occasion, "show me an educator who will raise a half-a-million dollars, assume the responsibility for irreplaceable art works and spend three years of his or her life to make a point, and I will show you a very good teacher." This is not intended to distort the museum's position in the art world. Rather, it is to point out the unique opportunities and responsibilities taken on by American art museum staffs who organize special programs, in addition to their responsibilities for taking care of some of the nation's most important cultural properties. They can do so only with the help of artists, scholars, collectors, only with the support of their visitors and patrons, all of whom become partners in these exciting and educational ventures.

Publishing at the Henry

I had not fully anticipated in 1978, my first year as Director of the Gallery, that a publishing program would develop so quickly. It soon became apparent, though, that there were many advantages—editorial, aesthetic and economic—to the Gallery and Association assuming responsibility for all aspects of production and distribution. Furthermore, in keeping with a change in focus from regional to national programming, there was a need to place the Gallery's "Index of Art in the Pacific Northwest" series in this larger framework. Our first publication in 1979 was the catalogue of our "Boyer Gonzales Retrospective Exhibition," followed by an Edward Kienholz catalogue and then our first book, *American Impressionism*, by William H. Gerdts, in January 1980.[8]

I have enjoyed participating in a dynamic program, one that has continued to evolve with the Gallery's programming ideas and through experimentation with formats, calculated risk taking, increasing sales and with the support of the Henry Gallery Association. The need for excellent art books is taken for granted, but the means for producing them is not. The Gallery staff includes an editor, a marketing head and a supervisor of sales (retail, wholesale and mail order). All other services are contracted for individual projects: design, photography, printing, binding, etc. Authors are usually guest curators or consultants during an exhibition's organization. Each member of the team contributes to the integrity of the whole but must function independently and assume responsibility for one particular aspect.

The Gallery has three basic publication formats: art books, exhibition catalogues and exhibition guides. Each tells a certain type of story, for a certain audience, and at a certain price. In principle, all major art history research efforts produce a special exhibition and a companion art book. Catalogues document other important exhibitions; those on exhibitions of contemporary art emphasize visual documentation and critical analysis, and catalogues on historical art present research.

The book format accommodates a lengthy text. Even though prepared in conjunction with an exhibition, it is treated as an independent statement, for the opportunities and responsibilities of publishing differ from those

of organizing exhibitions. The number of illustrations is never fewer than the number of objects exhibited, and other illustrations are included as required, e.g., works unavailable for loan or comparative works. Editing and design are tailored to the author's style, the content and the best means of presenting the art. A close relationship of text and illustrations has become a hallmark of the Henry Art Gallery's books.

Exhibition catalogues document the curatorial purpose and the objects included in an exhibition and acknowledge those who contribute to the exhibit and catalogue. The text of an exhibition catalogue is tied closely to the works in the exhibition and is necessarily more limited in focus than that of a book. A checklist is included for ready reference for the exhibition visitor and future researchers. Catalogues have fewer reproductions, fewer pages, and involve less preparation time and a smaller budget than the Gallery's art books.

Because we know that few Gallery visitors purchase and read our catalogues and art books while an exhibition is still on view, we prepare exhibition guides to briefly explain its purpose and introduce the artists. Guides presuppose less specialized knowledge on the part of the reader and present introductory rather than detailed information.

Posters and other exhibition graphics that are both commemorative and informative in function are produced by the marketing division. All publications and graphics are intended to be sold and are made accordingly. Text, reproductions, design and printing must be balanced in the totality. Otherwise the project expense and the efforts of each participant are compromised.

There are sound reasons why the Gallery and Association must continue to publish. A primary role of art museums, especially university art museums, is to document scholarship and critical analyses. Through the combined resources of the University and the community, we have been given the means to do so and thereby carry out our mandate as visual educators.

Floor plan of the Henry Art Gallery, 1926, Bebb & Gould, Architects. Courtesy University of Washington Archives.

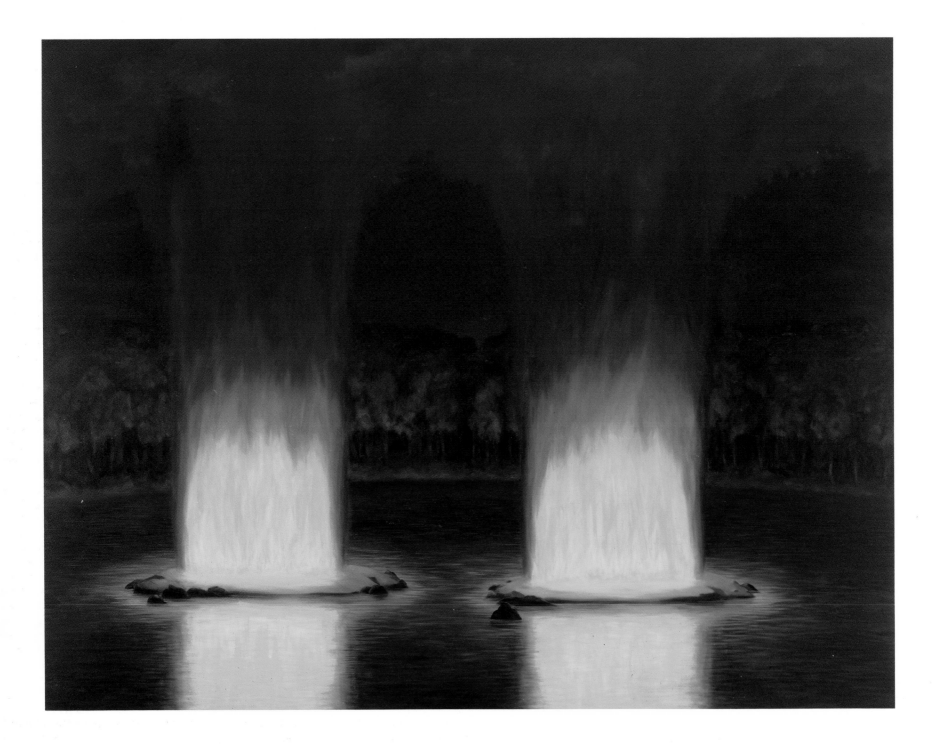

April Gornik

Two Fires. 1983

Oil on canvas
74 x 96 in
Private Collection

The Anatomy of an Exhibition

Sources of Light: At the Henry

The art works in this exhibition evidence the nature of contemporary luminism, its similarities to and differences from 19th-century luminism. They raise a further question, What are the sources of light in each painting or drawing?

Chris Bruce's insightful biographical sketches of the artists shed light on their upbringing, training, associations with fellow artists and artistic purposes. These biographies are the outcome of numerous telephone calls, meetings and correspondence Chris and I have had with the artists, discussing their creative evolution and the role that light and different light sources play in their work.

The artists represented here range in age from 32 to 57; and it is interesting to note that all but one, Alfred Leslie, spent at least part of their youth in the Midwest or studied there. During their artistic training each became familiar with modern theories of pure abstraction, but all concluded that they had the desire to depict the visual world, and the skills necessary to do so are evident. Two, Alf and Paschke, use projected photographic images as starting points for their pictures, and photographs have been used as references by Gornik and Lundin. Although the Leslie landscapes included here began as freehand sketches, Leslie's way of seeing and recording has been affected by his work in film and still photography, and here we see dramatic contrasts of black and white, with some middle grey tones. Brown's paintings seem to be the only ones without a photographic component, in method or luminosity.

All of the paintings and drawings in the show were created in the artist's studio. Some began with a photograph, a slide projection, a line sketch, others with visual memory; all were stimulated by light. Most have a single light source, some have more. Alfred Leslie's and April Gornik's luminist landscapes show us a wide range of sunlight effects. Martha Alf and Norman Lundin employ sunlight entering through the window of a room and falling on carefully composed objects. Roger Brown's "emblematic" landscapes and cityscapes are filled with natural and artificial lights, and Ed Paschke's light is electronic—both these artists show a light of the imagination.

Nature's light as shown by Gornik and Leslie—whether direct or reflected, sunrise or sunset, or the moon at night—calls to mind their attraction to nature. 19th-century landscapists such as Sanford R. Gifford, Frederick E. Church and Albert Bierstadt expressed the power and majesty of American nature in paintings of the Hudson River Valley, the western United States and locations farther afield; and in their paintings one can recognize actual locales, geological formations, waterfalls. It is important to remember that these painters' canvases were produced in a studio, often in New York City, based on drawings and/or painted sketches prepared on trips to the site. The paintings do, however, convey the artist's visual impression of the landscape, even if it was modified and conventionalized. There are striking similarities between the production techniques and visual concerns of these artists and Leslie and Gornik. Possibly the greatest difference is the lack of idealism so deeply felt by the painters of the Hudson River and the heroic American West.

The sun's light has for many centuries been supplemented by fire and candlelight and more recently by kerosene and gas light, but with the invention of the incandescent light bulb, fluorescent and neon tubes, and mercury vapor and sodium streetlights, artists were given a dramatically expanded vocabulary of light and our lives were changed. For many city dwellers, true darkness has almost ceased to exist—we can live in constant light if we choose. Therefore it is not surprising to find the rising or setting sun filtering through clouds above a road lit by the beam of a headlight in Leslie's "Views Along the Road" or an incandescent interior placed before a stylized sunset by Brown. Paschke takes us inside an electronic light field, eliminating any other. Because of our near addiction to television, however, his light source is immediately identifiable.

Luminosity is created in these pictures with traditional materials and techniques: oil paint applied to a canvas with brushes; inky watercolor, graphite, colored pencils or pastels on paper. The Gallery's study of contemporary American luminism could have been expanded to include Dan Flavin or Robert Irwin or James Turrell. Each has added new dimensions to the aesthetics of light. However, given a limited amount of space and the fact that the fixtures or installations would have contrasted with the materials used by the others, it was decided not to expand the visual possibilities in that direction.

Because of the convincing illusion presented in many of these paintings and drawings it is hard to imagine the artist carefully manipulating the space, form, texture and color, time and time again. But the 20th century's romance with abstraction has not gone unnoticed by these artists. When many modern American artists chose to concentrate on abstract composition and other purely pictorial elements nature was replaced by a conscious effort to give painting a purely aesthetic rationale; representation was frowned on and so-called literary reference banished. The work of the artists in this exhibition and many others indicate an alternative to such reductive theories, yet they too are heir to the lessons of the abstractionists—their understanding of purely formal values is evident. It is impossible to look at almost any one of the works included and not see a very deliberately conceived composition. On the other hand, it would be wrong to suggest that a desire to draw from their visual world

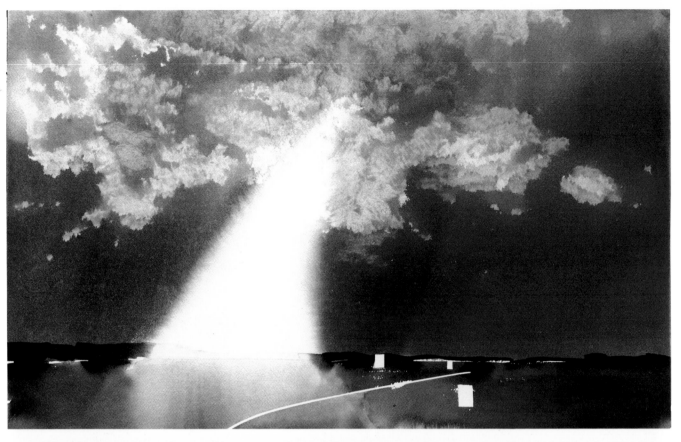

does not play a major part in the work of these artists. Martha Alf summed up the situation when she described her work of the early seventies as "color field representational painting."[9]

In lieu of drawing real objects or space, an intermediate photographic step is used by some of these artists. Photographs do afford a studio convenience, and the camera offers another way of recording the world than traditional drawing techniques. However, one cannot help but wonder what is missed when the recording of a natural phenomenon is not linked to direct observation of the subject and affected by changing conditions. Plein air painters of the late 19th century took great pride in their ability to paint the subject directly. Monet's systematized method for working on a sequence of canvasses representing specific times gave each painting a distinctive quality due to the changes in the light he observed. The variations originated in changes in the subject, not in subjective changes induced by the artist's hand as is the case with Martha Alf's differing versions of the same source image. Considering the liberty taken by each of these artists in their compositions, it is difficult to determine the influence the photographs actually have on their art, except that the ranges of light and dark have a photographic quality. Regardless of my admiration for direct observation and recording, the camera is part of the contemporary studio and has had considerable influence on modes of representation in art. Yet, the works presented here could not have been produced without the artists' skill in drawing and their clear understanding of traditional materials and their use.

Alfred Leslie, the senior artist of the group, has enjoyed a growing reputation for the past two-and-a-half decades. Always independent of the American art mainstream, he has made innovative contributions to it. He painted portraits when they were not considered acceptable subjects, narrations when stories were not to be told, and then luminous landscapes; he is now painting landscapes at the sites of famous 19th-century paintings.

The black-and-white "Views Along the Road" were created by a seasoned painter

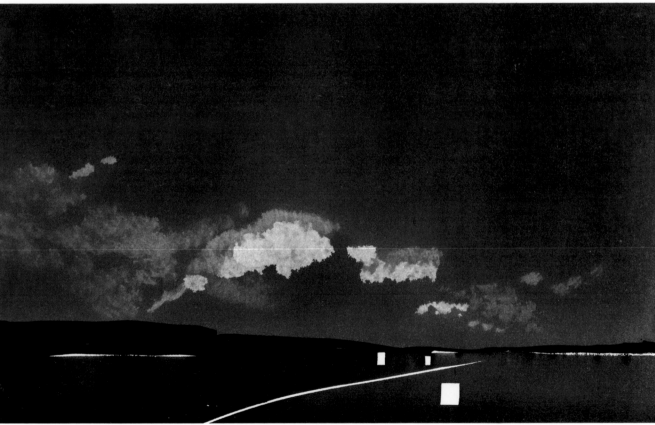

Alfred Leslie

Heading for Gallup, New Mexico. 1977-81
Watercolor on paper
18 x 24 in
Courtesy of the artist and Oil & Steel Gallery, New York

Heading for Gallup, New Mexico. 1977-81
Watercolor on paper
18 x 24 in
Courtesy of the artist and Oil & Steel Gallery, New York

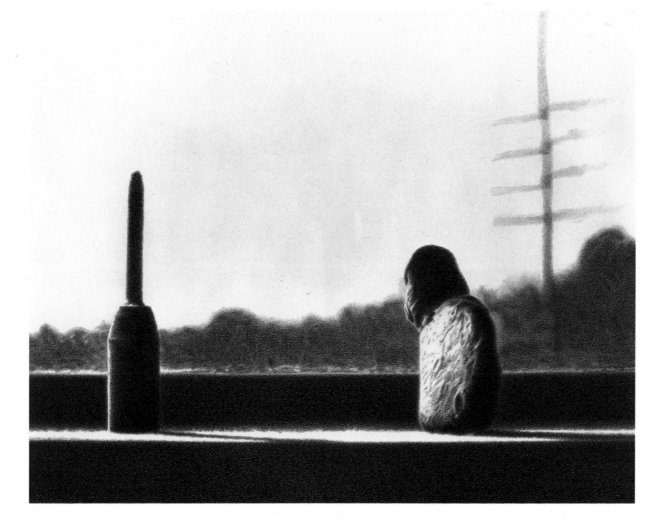

determined to surmount the technical and artistic problems involved. These watercolors record an America split by interstate freeways, dotted with cities and dramatized by light. The source of light is placed near the horizon, and it is impossible to tell whether one is viewing a sunset, sunrise or moonlit landscape. Traffic signs, a drive-in theatre screen, power lines and lamp posts are illuminated by an unseen source, usually by the headlights of the car in which the artist was riding. A fog shrouding Youngstown conceals industrial blight, and these artistically edited cityscapes must be considered beautiful. Rather than expressing a judgment on urbanized and industrialized America, this series show us that the works of nature and man are as capable of artistic definition as the primeval forest of the last century.

Leslie began with sketches of his on-site observations, and in the studio solved the artistic problems they presented. The paintings reveal Leslie's appetite for the formal possibilities afforded by his subject. Although photographic mediation was not directly involved in their making, these pictures do evidence Leslie's background in photography and filmmaking.

April Gornik's paintings of idealized, luminous landscapes reintroduce a grand tradition of American landscape. Fortunately, this coincides with dramatic changes in what is currently "acceptable" in art. Their size suggests they are exhibition pieces (like salon paintings of the last century). These paintings are similar in scale to those of Albert Bierstadt, who over 100 years ago used similar studio techniques to create monumental landscapes in the Tenth Street Studio Building, just north of where Gornik paints today. Bierstadt changed the American landscape to look more like the Alpine views of his European homeland, and Gornik too combines observation and imagination—each picture speaks of her nature.

Martha Alf

Objects on a Windowsill No. 1. 1982-83

Prismacolor pencil on bond paper
11 x 14 in
Courtesy of the artist and Newspace Gallery, Los Angeles

The source of light and time of day is clearly defined. In many of Gornik's paintings there is an evening calm with somewhat surreal overtones, which while not natural, are never threatening. The landscape and the sunset reassure the viewer that there will be another day. This makes her luminism more traditional than Leslie's. She uses light to articulate the anatomy of the clouds, the surface of the water, the silhouette of the mountains.

Martha Alf is a classic American luminist. Although light is a dominant element in the work of the other five artists, for Alf it is the subject. Since 1975 when she began her monochromatic drawings of fruit, Alf has consistently examined light and its effect on common objects. It is not possible to stand in front of her drawings and not come to the same conclusion that Joni Gordon did. That the objects and the space are almost incidental to her art is suggested by their repetition with so little variation. Although the objects are selected after careful consideration, the process is so personal that it is not easily accessible to the viewer, for whom the perception of correctly rendered everyday objects suffices. And the objects are supports for the study of light and its play. The only momentary diversions from light and its color are provided by Alf's flawless drawing technique and her control of illusionary space.

Alf's studies of light are similar in many ways to the landscapes of Martin Johnson Heade. Heade painted fields with sunlight playing off stacks of hay, moving them around in variation after variation; Alf uses pears. Heade's vista was the open landscape, hers the windowsill or tabletop. Both painters work on an intimate scale and invite a close examination of the light.

In many of Alf's still lifes the edges glow, as in *Two Pears No. 3 (for Michael Blankfort)*. She often uses backlighting, an interest she shares with Leslie (in *Outside Laguna, New Mexico*, for example) and with Brown (*The Black Hills*). Alf's light source, though, is the same as Norman Lundin's—sunlight streaming into a room through a window. The juxtaposition of Alf and Lundin in this exhibition and catalogue is deliberate, based on their shared interest in portraying common objects in the studio and their classical draughtsmanship.

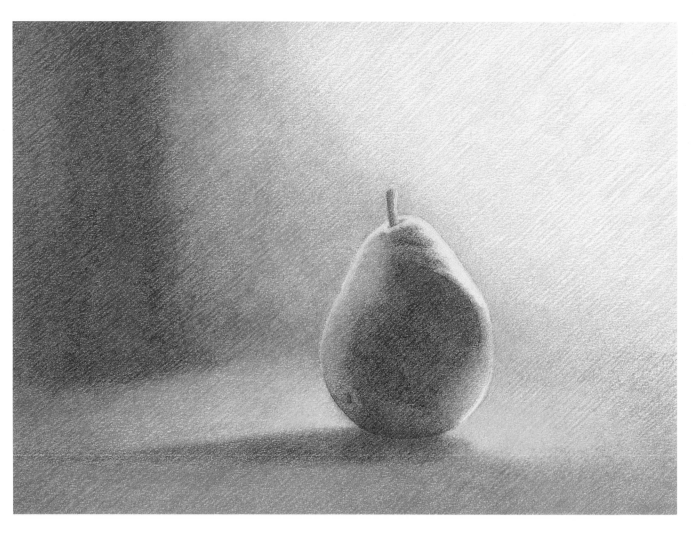

Martha Alf

Pear No. 1 (for Andy Wilf). 1982

Pastel pencil on bond paper
12 x 18 in
Collection of Mr. and Mrs. Barry Sanders

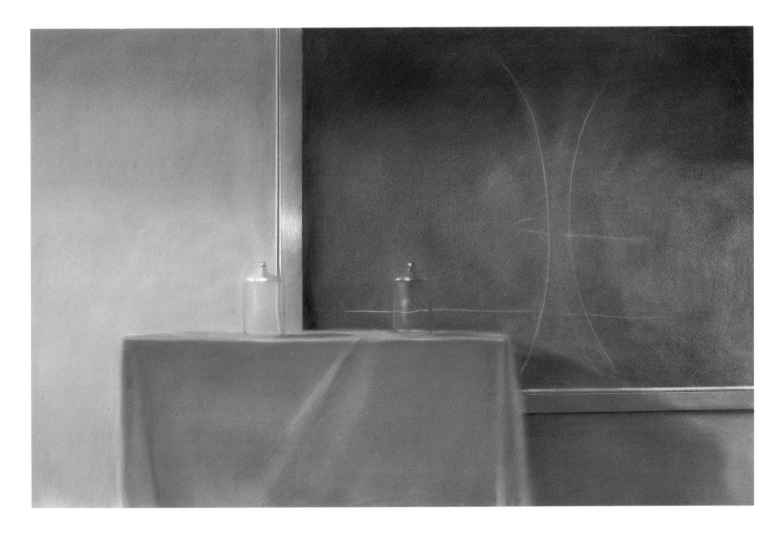

I have had the pleasure of knowing Norman Lundin for the past 15 years and have observed his choice of similar subjects and his consistent use of graphic materials. His is an art built on subtle variations. In the last three or four years, with few exceptions, his drawings have been of exquisitely simple interiors punctuated with one or two carefully placed objects—or totally empty. Solitude has been a consistent quality. When figures are introduced they seem as motionless and isolated as the stools or packages, introduced for pictorial balance in much the same way light is introduced to enliven the composition and provide tonal variation. Light is not the subject as it is for Alf, and Lundin works with a more restricted range of values than she. But their temperaments and overall aesthetics are similar.

Lundin's luminism is becoming more conscious. In 1983 he made three "60th Street Studio" drawings subtitled "About 6:30 AM," "About 8:00 AM" and "About 10:00 AM." The light often imparts a sheen, created to some degree by the rubbing or stumping of the dry pigments. Yet, such accents come from formal necessity rather than a desire to depict luminosity itself. Similarly, he adds color for accents, as in *Orange Table Cloth and a Blackboard*. One senses the artist searching for the perfect location of an electrical conduit or the edge of a blackboard so that the form and its highlighting will harmonize and give a balance to the whole; the same is true of the diagonal beams of light. Rather than starting with the recording of natural light "out there," Lundin introduces light in a carefully controlled manner and for compositional purposes.

Norman Lundin

Orange Tablecloth and a Blackboard. 1983

Pastel on paper
28 x 44 in
Private Collection

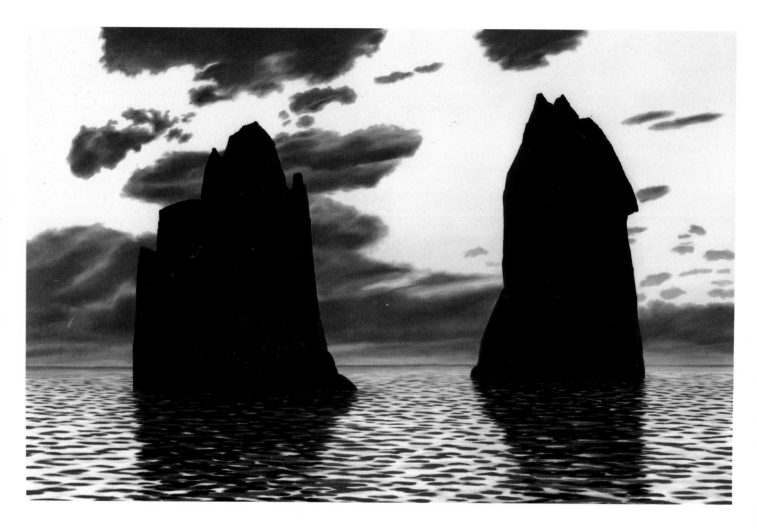

April Gornik

Equator. 1983

Oil on canvas
74 x 116 in
Collection of Laura Carpenter

Ed Paschke's psychedelic light is familiar to a certain generation. Being roughly the same age, I recognize the origin of his palette. When seeing his paintings, many will surely recall our collective appetite in the sixties for bright colors: dayglo greens, lime yellows, fluorescent purples and blues. They couldn't be too strong. Colors, sounds and attitudes were confrontational in their intensity and intent. The mood of the sixties still underlies Paschke's paintings of the eighties: being in a gallery filled with these paintings is like being in a room whose illumination is a cross between black light and video. There is an allover brightness, not the isolated intensity of a single, directional light source. Paschke's paintings seem to be plugged in.

First known for his aggressive, politicized figure paintings, since 1978 politics have been sublimated to Paschke's study of character and its media-tion. The light seems threatening because it vaporizes people. They lose their individual identities and become unrecognizable, like those in *Tres Lindos*. Paschke's initial image projections on the blank canvas introduce figurative images that are dematerialized through light and color. The television screen's synthetic light and color give Paschke's work an urban, "now" look without historical precedents. However, luminism of a different sort is clearly a major part of his art-making. The Gallery exhibited earlier works by this artist in the fall 1984 exhibition "Strange" because of their commanding and powerful images. Paintings executed after he began to be influenced by video images were selected for this exhibition, with his concurrence that light was a major concern during this period.

Roger Brown shares Gornik's and Leslie's interest in luminist landscapes and cityscapes, but the stylistic differences are striking. Brown's manner is akin to naive painters in that it is more symbolic than naturalistic, relies less on direct observation and lends increased possibilities for abstraction. The most purely abstract of the six, Brown is a painter first. One cannot stand in front of his large landscapes such as *Big Sky* and not feel the weight of the sky, the clouds lit by the sun setting behind them, pressing down on the land. This light

Norman Lundin

Sunset Hotel No. 1. 1984-85

Pastel on paper
44 x 28 in
Courtesy of the artist and Francine Seders Gallery, Seattle

seems "natural" only in contrast to the yellow incandescent light inside a building or vehicle, silhouetting its occupants. While Brown is a luminist painter, light is employed to further expressive more than representational ends. He tells stories set in locations that combine a "once upon a time" element with actual places— Chicago, Malibu or the Black Hills. One is always left with the sense of an episode and a specific time, often sunset.

The same joy of painting seen in Brown's oils is evident in Leslie's watercolors. Both artists share an enthusiasm for paint and brush. Brown's sense of pigmentation is exceptional. The trailed edge of the brush laying down oil paint treated with varnish gives the titanium whites, cadmium reds and thalo blues a vibrant sheen. The illusion he creates with value changes is magical. A dark color brightened with a light edge creates a spatial shift and establishes light behind the shape.

This exhibition presents paintings and drawings that are examples of contemporary luminism. The Gallery is responsible for using that term—although the six artists agree that light is a key aspect in their work, none had previously called themselves "luminists" nor do they now. They are talented, productive individuals who have many creative years ahead of them and during that time will pursue a variety of ideas and visual possibilities in addition to the study of light. Their work will be evaluated and re-evaluated well into the future, and in that process other characterizations will be added to the one made here. We have directed our attention, and yours we hope, to certain recent works and the special qualities and sources of light in each. Our curatorial purpose has been to investigate one aspect of contemporary art-making and the artistic intent of six practitioners—and to share the results with you. In conclusion, I would like to state some observations that were made during the organization of the exhibition and the preparation of this catalogue.

After viewing these pictures, one may conclude as I have that the light in them is artists' light. Rather than being the product of recorded observations, light has been abstracted for compositional or expressive ends through studio processes involving

the selecting, editing and manipulating of imagery, sometimes combined with a reliance on photography. These artists have understood the formal possibilities of light, whatever its source. Those portraying natural light prefer a source near the horizon rather than high overhead, thus providing drama. Whether the time is early morning, evening or moonrise is of less importance than the location of the light source and the fact that it gives a great variety of lights and darks. This permits the artists to explore marked contrasts, as Alfred Leslie often does, or, as can best be seen in the work of Martha Alf, a wide range of values. These in turn provide much of the compositional structure and give these pictures their staying power. Ed Paschke's light source, being totally synthetic, differs from that of the other artists, but its electronic blast is highly dramatic.

The opportunity to ask a question about the nature of contemporary art, carry out the necessary preparations, and learn from the artists and their art has made "Sources of Light: Contemporary American Luminism" a very special project for those who participated in its organization. Although our formats are standard ones—exhibitions, books, lectures— the answers they provide are always educational and add to our collective understanding and appreciation of art. In the final analysis, the opportunity to build on this experience and look at art more discerningly is the greatest reward.

Ed Paschke

Tres Lindos. 1982

Oil on canvas
42 x 80 in
Collection of Arthur and Carol Goldberg

Notes

1. Horace C. Henry (1844-1928) was a contractor, developer and philanthropist who began collecting paintings in 1893. In the 1910s he began opening his Seattle home to the public for viewing of the collection, and in 1917 built a gallery adjoining his house. He donated the collection to the University so that it would be "appreciated by large numbers." It consists primarily of landscapes, having a concentration in American Barbizon and examples of their French forebears.

2. The Henry Collection originally filled four of the galleries, with two smaller ones being used for special exhibits. Although works from the permanent collection were exhibited on occasion, selections have varied over the years. From 1928-78 the special exhibitions organized by the Gallery were drawn primarily from regional resources.

3. It is our intention to install other late 19th- and early 20th-century paintings and sculpture to complement the Horace C. Henry Collection and place the Henry Art Gallery on the National Register in order to preserve the building's original use. Expansion of the University's art museum would proceed as independent facilities are built to house and exhibit other portions of the collections as well as present special programs.

4. John Wilmerding, et. al., *American Light: The Luminist Movement, 1850-1870; Paintings, Drawings, Photographs,* (Washington: National Gallery of Art with Harper & Row, 1980); William H. Gerdts, et. al., *Tonalism: An American Experience,* exh. cat., (New York: Grand Central Art Galleries, 1982); idem., *American Impressionism,* exh. cat., (Seattle: Henry Art Gallery, University of Washington, 1980); idem., *American Impressionism* (New York: Abbeville Press, 1984).

5. Organized by the Fellows of Contemporary Art, Los Angeles, curated by Josine Ianco-Starrels, and shown at the Los Angeles Municipal Art Gallery and the San Francisco Art Institute.

6. The William Merritt Chase Retrospective Exhibition was composed of 100 works, selected for the Gallery by Ronald G. Pisano, author of the book *A Leading Spirit in American Art: William Merritt Chase, 1849-1916,* copublished by the Henry Art Gallery and the Henry Gallery Association. After its October 2, 1983-January 29, 1984, showing at the Henry, a modified form of the exhibition traveled to The Metropolitan Museum of Art, New York (March 9-June 3, 1984).

7. The Henry Gallery Association was initially formed to support exhibitions of contemporary art and their documentation.

8. *Boyer Gonzales: The Painter, A Retrospective Exhibition 1930 to Present; Edward Kienholz: Sculpture, 1976-1979; American Impressionism.*

9. Quoted by Suzanne Muchnic, in *Martha Alf,* exh. cat., (Los Angeles: Fellows of Contemporary Art, Los Angeles, and Los Angeles Municipal Art Gallery, 1984), p. 20.

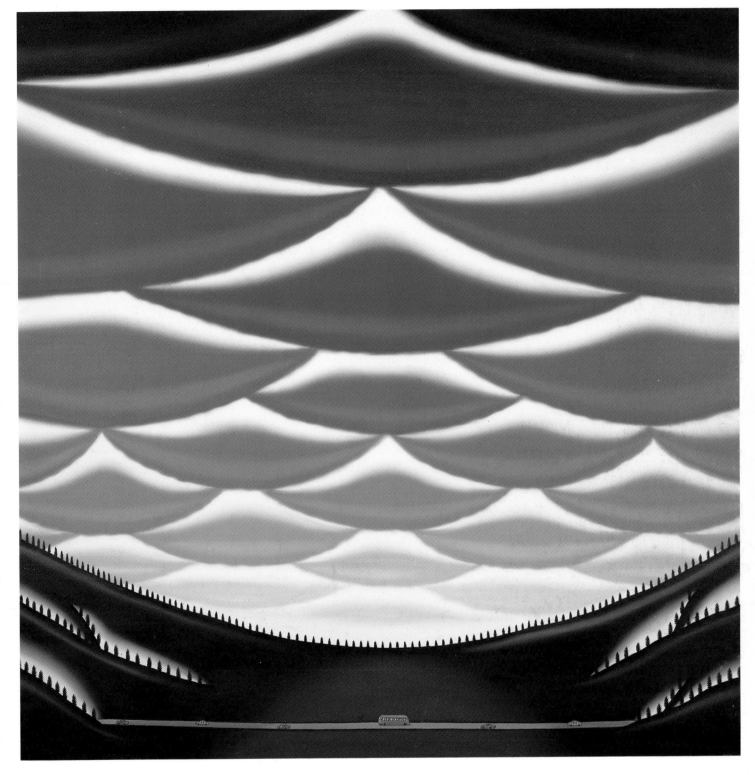

Roger Brown

Big Sky. 1979

Oil on canvas
72 x 72 in
Collection of Mr. and Mrs. Edward Byron Smith, Jr.

Alfred Leslie

1927 Born, October 29, New York, New York

1947-49 Art Students League and New York University, New York, New York

Lives and works in South Amherst, Massachusetts, and New York City

"To me notan means a perfection of the relationship of black and white....The word has less to do with technical matters than with the belief that there can be an unchanging response to the certain beauty of just so much black related to just so much white."*

Alfred Leslie's education has come from an almost 40-year, roll-up-the-sleeves involvement with artists who have participated in theater, music, dance, film, poetry and the visual arts. Except for a one-year nine-month, 16-day "course of study" at New York University—the exact amount of time he was allowed G.I. benefits—his artistic training has been on the street and in the studio. Fortunately he chose the right stint at New York University, however. William Baziotes and Tony Smith had recently joined the faculty, and fellow students included Larry Rivers and Robert Goodnough. Leslie also had the good fortune to be in the right city at the right time, in that he was able to enjoy an especially creative flowering of art in this country. It is to his credit that he has made such a significant contribution to it, even during the years in which he had to work at jobs that ranged from floor waxer to house painter, carpenter to fabricator of plastic novelties, trucker to railroad yard brakeman. There were times when he was so broke that he sold his blood to local hospitals. Yet, his artistic activities, friendships and creative production during any one phase of his career would suffice to make a full and gratifying life for most people. Leslie is someone who enjoys grappling with an idea, making it real, and all the personal associations that it brings.

His endeavors have always reflected the energy and strength of someone full of life, and his ideas have manifested themselves in a variety of media. As early as 1947, Leslie felt a conflict between his abstract painting and his descriptive pursuits such as filmmaking. This was a time when many people crossed over between the different arts, and also a time when "serious painting" was essentially Abstract Expressionist. By Leslie's first one-man show in 1952, however, half his work was figurative. He would "muddle," as he puts it, between abstract and figurative work until the early sixties when he decided that abstraction could not express his real aims.

In his *Contemporary American Realism Since 1960* (1981), Frank Goodyear called Leslie (along with Jack Beal) one of the "two most important narrative painters in America today." And it is easy to see why. He has made films regularly since high school, has shown in numerous film festivals through the years, and he was one of the founders of the New American Cinema in the late fifties. In 1956 Leslie and the great documentary photographer Robert Frank formed their own production company, and with Jack Kerouac as a third partner made *Pull My Daisy* (this film included Allen Ginsberg, Larry Rivers, Gregory Corso, Alice Neel and Richard Bellamy among others). Leslie further expanded his narrative pursuits to include audio tapes in 1959, in the way of "found operas" and sneak interviews. Equally outrageous was a "facsimile" novel of James Joyce's *Ulysses* in which he rewrote each sentence using different words to produce the same meaning.

Persistence and endurance coupled with his poetic mind have allowed him to stay with projects such as the *100 Views Along the Road* (from which the works in this show are drawn) and the *Killing Cycle* (1966-80), a series of several hundred drawings and five large paintings that movingly commemorate and come to terms with the accidental death of Leslie's friend, the poet/critic, Frank O'Hara. There is a cinematic quality in both these series, and in many other of his paintings and drawings as well. The strong light from a single source and the high contrast are constant throughout his work, something that certainly reflects his experience as a photographer/cinematographer. Leslie calls the *100 Views* "notan studies," using a Japanese term employed by Arthur Wesley Dow to describe the perfect relationship between lights and darks in two-dimensional composition. The simple elegance of these studies is deceiving, for they were in progress for well over a decade. It is telling of Leslie's method that he would spend that much time on such a single— and troublesome—pursuit: they are much more than someone's travel sketches or souvenirs of a trip.

The notan series began in 1967 in an attempt to resolve the effects of light and atmosphere in one of the *Killing Cycle* paintings. After an initial and chance success with the first black-and-white study, subsequent watercolors simply would not work, and became an intriguing problem on their own. Sensing something in them that was worthwhile, Leslie continued to work. It took years before anything really pleased the artist. In 1977, the Leslie family went to Santa Barbara for ten weeks, and Alfred spent all of his free time painting traditional, plein air watercolors: "The result was awful." On the way home he made numerous drawings from inside the car as it moved through the beautiful land-scapes across the country. Upon reaching Massachusetts, he vowed to solve the problem of the watercolors. After many more failures, he returned to the black and white he had used over a decade before, and finally one worked. He began redrawing all of the sketches and paintings from the trip and then painting them in black and white. After finishing about 40, Leslie realized he had something of an American roadside journal, and decided to give it a cohesiveness and limit it at 100. The paintings were actually produced over a one-and-a-half year period.

Leslie has had many studios in New York through the years (he organizes his personal chronology according to the periods of time spent in each studio). His current one is north of the Village in a refurbished building that he co-owns. It serves largely for portrait work and as a place to stay in Manhattan, for while he lives most of the time in Massachusetts, it would be nearly impossible for him to cut his ties with New York. "You've got to survive," he explains, which seems to be meant in a cultural and spiritual sense.

The Massachusetts residence came about as the result of a fire that destroyed his large New York studio on October 17, 1966. Leslie was using the studio on 13th Street too, but it is small, and he needed quite a bit of room to work on one of the *Killing Cycle* paintings, for which he wanted to set up a tableau including a real Jeep for a model. Right about that time he was offered a one-year teaching position at Amherst. He accepted when the college agreed to provide studio space *and* help procure an Army surplus Jeep. Alfred, Constance and their three children now live on a 30-acre farm in a rural area, surrounded by dairy and tobacco farms. The recent studio addition is the only even remotely large room, and it is where the *100 Views* were produced. What began as a temporary stay has been prolonged in part because of an extended project involving a series of paintings based on "discarded" historical landscape sites, specifically some of those found in the works of Thomas Cole and Frederick Edwin Church, who produced so many great luminist paintings.

Alfred Leslie: 100 Views Along the Road, exh. cat. (Youngstown: The Butler Art Institute, 1984), unpaginated. All other quotes from the artist come from a chronology prepared by him or from telephone conversations (January 1985).

Alfred Leslie

Approaching the Grand Canyon. 1977-81

Watercolor on paper
18 x 24 in
Courtesy of the artist and Oil & Steel Gallery, New York

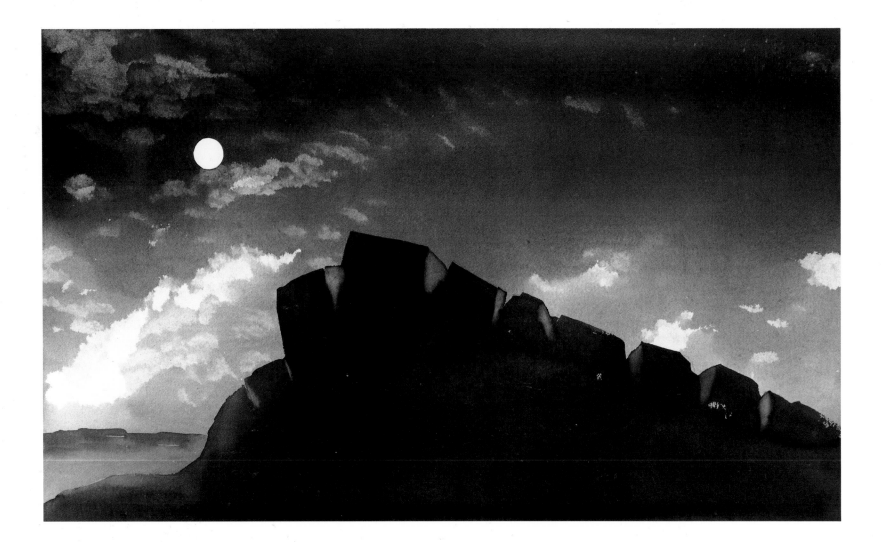

Alfred Leslie　　　*Outside Laguna, New Mexico.* 1977-81

Watercolor on paper
30 x 42 in
Collection of Robin Wright Moll

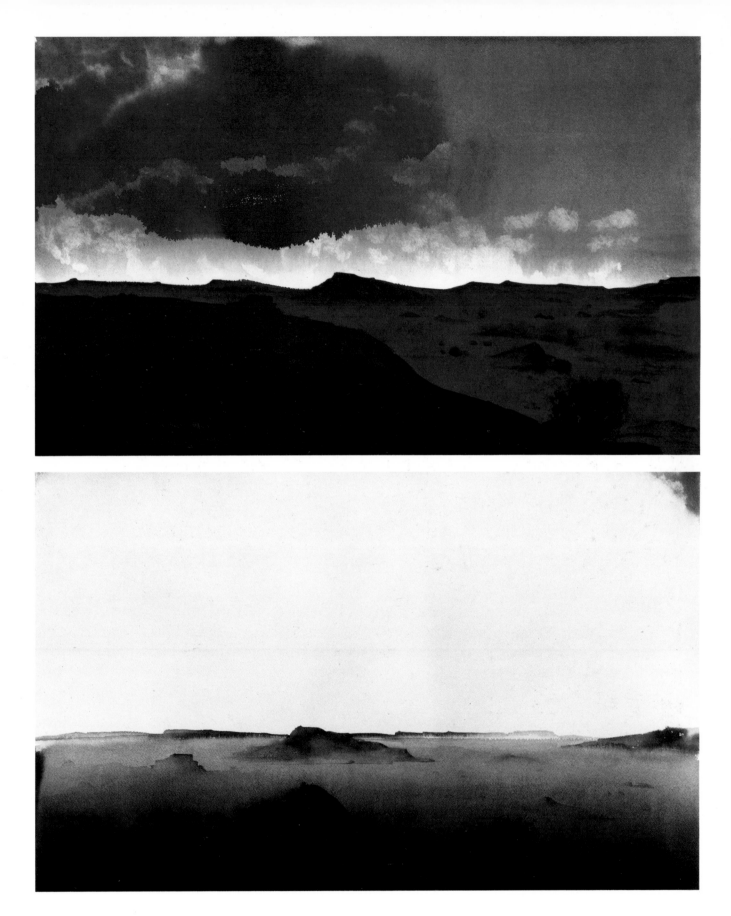

Alfred Leslie

The Painted Desert. 1977–81

Watercolor on paper
18 x 24 in
Collection of Jane Timkin

The Painted Desert. 1977–81

Watercolor on paper
18 x 24 in
Collection of Jane Timkin

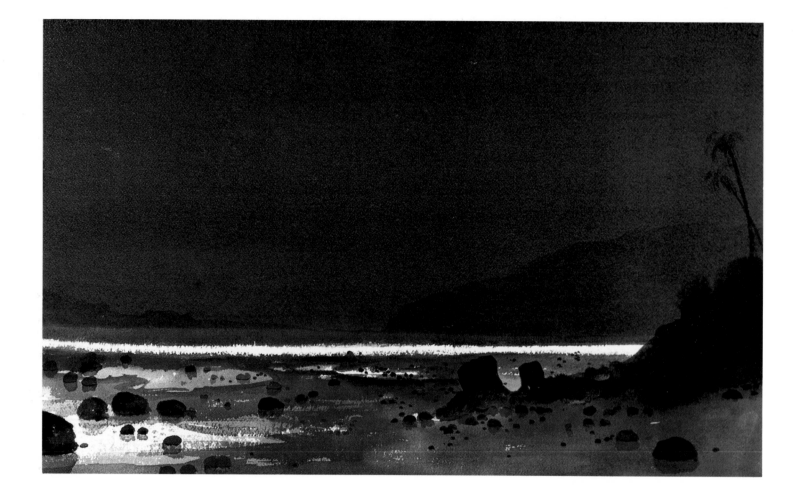

Alfred Leslie *Rocky Beach: Santa Barbara, California.* 1977-83

Watercolor on paper
18 x 24 in
Courtesy of the artist and Oil & Steel Gallery, New York

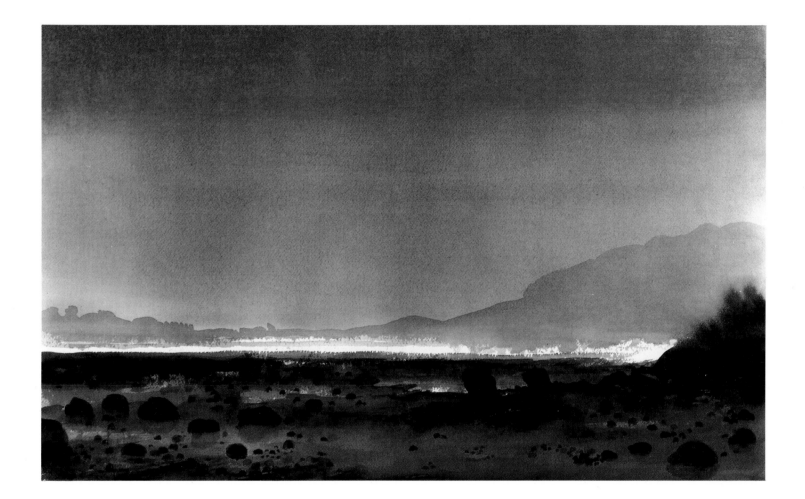

Alfred Leslie

Rocky Beach: Santa Barbara, California. 1977-83.

Watercolor on paper
18 x 24 in
Courtesy of the artist and Oil & Steel Gallery, New York

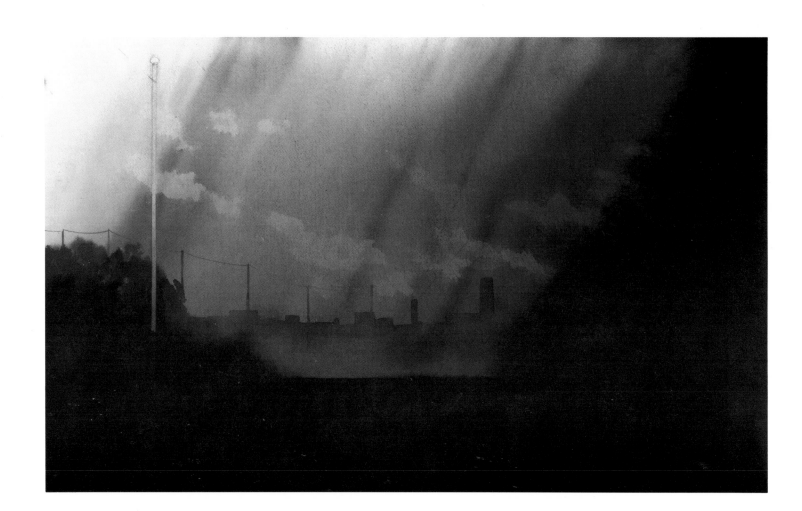

Alfred Leslie

*Bridge from Mill Creek Park,
Youngstown, Ohio.* 1983

Watercolor on paper
18 x 24 in
Collection of Mr. and Mrs. Bagley Wright

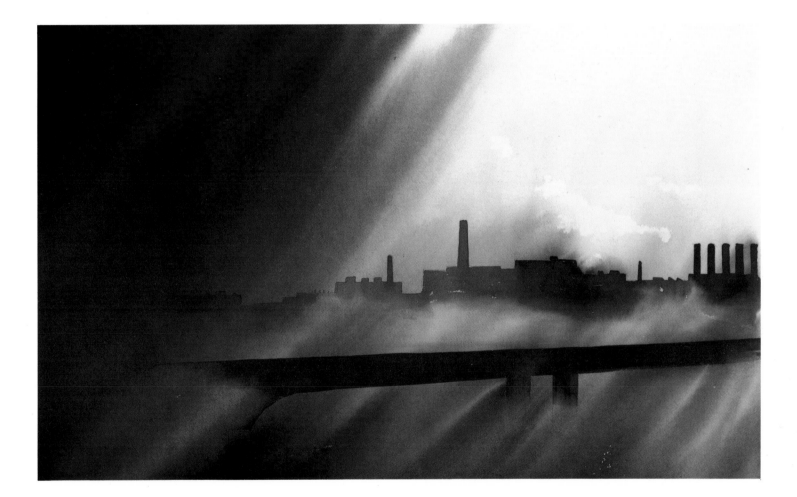

Alfred Leslie

***Bridge from Mill Creek Park,
Youngstown, Ohio.*** 1983

Watercolor on paper
18 x 24 in
Collection of Mr. and Mrs. Bagley Wright

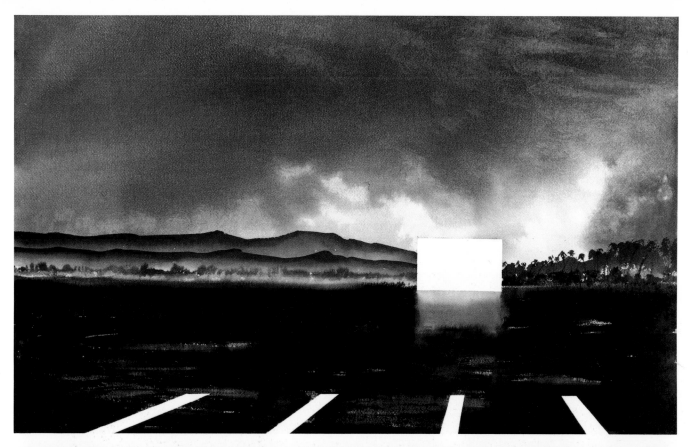

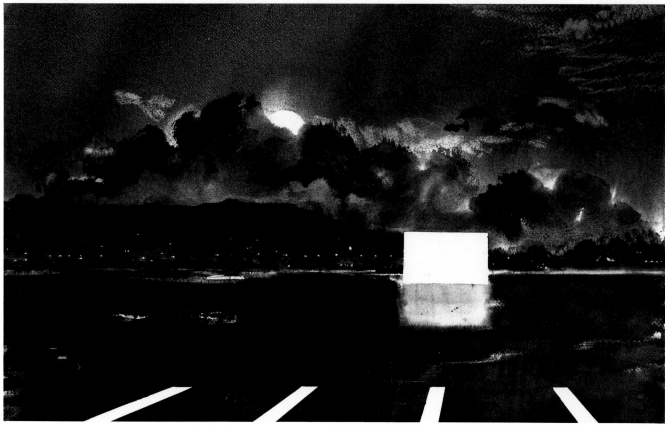

Alfred Leslie

Drive-In Movie, Santa Barbara, California. 1977-81
Watercolor on paper
18 x 24 in
Courtesy of the artist and Oil & Steel Gallery, New York

Drive-In Movie, Santa Barbara, California. 1977-81
Watercolor on paper
18 x 24 in
Courtesy of the artist and Oil & Steel Gallery, New York

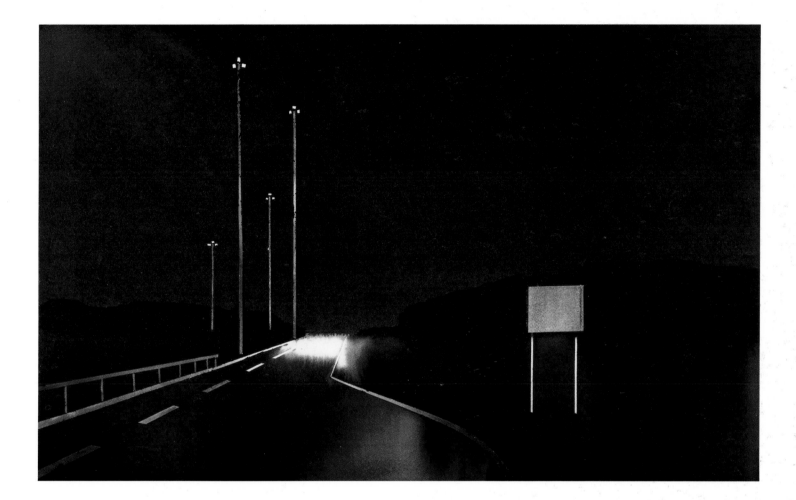

Alfred Leslie

Entering 91 at Holyoke, Massachusetts. 1983

Watercolor on paper
18 x 24 in
Courtesy of the artist and Oil & Steel Gallery, New York

April Gornik

1953 Born, April 20, Cleveland, Ohio

1971-75 Cleveland Institute of Art,
Cleveland, Ohio

1976 B.F.A., Nova Scotia College of Art and
Design, Halifax, Nova Scotia

Lives and works in New York City

"My favorite quote is from the movie 'Fata Morgana' by Werner Herzog. 'In paradise you can cross the land without seeing your shadow; there is landscape without any deeper meaning.' ...Landscape, and how 'out there' it is, is the most abstruse, the most dissimilar to human experience and scope of all representational possibilities. It is local Outer Space."*

April Gornik paints landscapes that have a 19th-century look, and yet embody a very contemporary vision. Their slightly surreal realism may evoke the luminist paintings of the past, but they are basically naturalistic fictions, landscapes representing inner spaces. Their otherworldy quality is important to her. Gornik points to a very normal suburban upbringing as something that forced her to turn to fiction if she was to have any sense of richness in life. The sky was another way to reach beyond suburbia: she remembers that when she was little she would go outside and look for storms.

As an art student in the early seventies, Gornik got caught up in the most current expression of the day, conceptual art. It is interesting to note how the other artists in this show had to wrestle with Abstract Expressionism before settling into their own representational styles. But, in Gornik's case the prevailing excitement centered on conceptual art, which denied art traditions in a different way (by reference to other fields such as mathematics, physics, philosophy, etc.). Gornik found herself rather stifled in Cleveland, partly because of a general lack of interest in conceptual work, partly because it was home. The opportunity to attend Nova Scotia College arose, and she went, largely on impulse. It had what she wanted: a young faculty that was concerned with theory and that leaned heavily towards the avant-garde, as shown by the fact that Joseph Beuys was her commencement speaker. Then there was "the other faculty"— the painters, among whom were Richards Jarden and Eric Fischl, her future partner. After a time, the way most conceptual art justified and "patched up" itself by using other disciplines began to wear thin for Gornik. She began to see how the history of art had merit, and how traditional art really had its own rationale. By the time she finished her B.F.A., Gornik had decided to go to Europe rather than graduate school.

The trip to Europe in 1976 firmed-up her notions about "the reinforcing power of art as a tradition." She went alone, and stayed alone most of the time, going to every museum she could find. For two months, she hardly talked to anyone, stayed in cheap hotels, ate little, and looked at art all day long. In addition to the fact that she found she liked being alone (remember, there are never people in her paintings), art began to change for her. She started out a conceptualist who was beginning to use paint ("as information" as they would say in the seventies), and her initial interest in museums was in seeing the tribal art. Before long, though, the paintings began to interest her greatly. When she saw Vermeer's *View of Delft* she "was struck dumb with amazement." Its luminosity and perfection of scale had a profound impact, and Gornik is very much concerned with these values in her own painting.

She returned to Halifax, where she worked as a waitress, and then she and Fischl went to Europe for three-and-a-half months. When they returned, they decided that Halifax was too limiting. April, particularly, wanted to test her artistic abilities and ambitions, and she prevailed upon Eric to move to New York. They now live in an older business district south of Soho, in a loft space that includes April's studio.

A painting begins with small sketches to work out the image, which is then translated to the canvas with pencil and finished in the traditional manner of oil painting. Gornik works on as large a scale as she physically feels comfortable with, so that the paintings can engulf the viewer while offering an open-ended spaciousness. Because these paintings are so large, each one takes quite a bit of time and goes through numerous changes and refinements of "tension" and color. The paintings are essentially composites of imagination, experience in nature, and photographs used as references for certain visual phenomena. Gornik also draws inspiration from reading: her love of fiction has remained. For instance, the title of *Cloud Wall* (1983) refers to the fantastic cloud wall that hovers over the New Jersey marshes in *Winter Tales,* by Mark Helprin. *Two Fires* was inspired in part by D.M. Thomas's *The White Hotel.* Even though one can cite literary sources for these works, they are primarily and essentially imaginary places in the mind of April Gornik.

The landscapes are intended to have a dramatic "otherness" about them. The artist talks about "making a painting which has an experiential psychological quality" so that the viewer can project him- or herself into it freely without the intrusion of any narrative element. Gornik purposely excludes figures, and in this way harks back to conceptual art in that the paintings are set up as "situations" rather than records or expressions of an event.

Gornik obviously approaches art from an intellectual point of view, and yet the things she finds moving are quite visceral. For example, the repetitive use of two major structural elements in many of the paintings came from an incident in Arizona. She and Fischl were in a boat far out in Lake Powell, the huge reservoir created by Glen Canyon Dam on the Colorado River. The land there is stark as a rust-colored moon, and giant, sheer buttes jut out of the water without pattern or logic. Suddenly, a dusty red glow appeared on the horizon and a ferocious storm came up. To reach the dock they had to head straight into the storm, and speed between two huge rocks, much like those in *Equator* (1983). Even such a specific occurrence gives rise to a philosophical or psychological interpretation: this one has led her to associate the number two with an archetypal portal or entryway as well as a situation that presents a choice. But, ultimately she says, "I really do love beauty."

Paradise Lost/Paradise Regained: American Visions of the New Decade, American Pavilion, 41st Venice Biennial, exh. cat. (United States Information Agency, 1984), p. 106. All other quotes are taken from conversations with the artist (December 1984, January 1985).

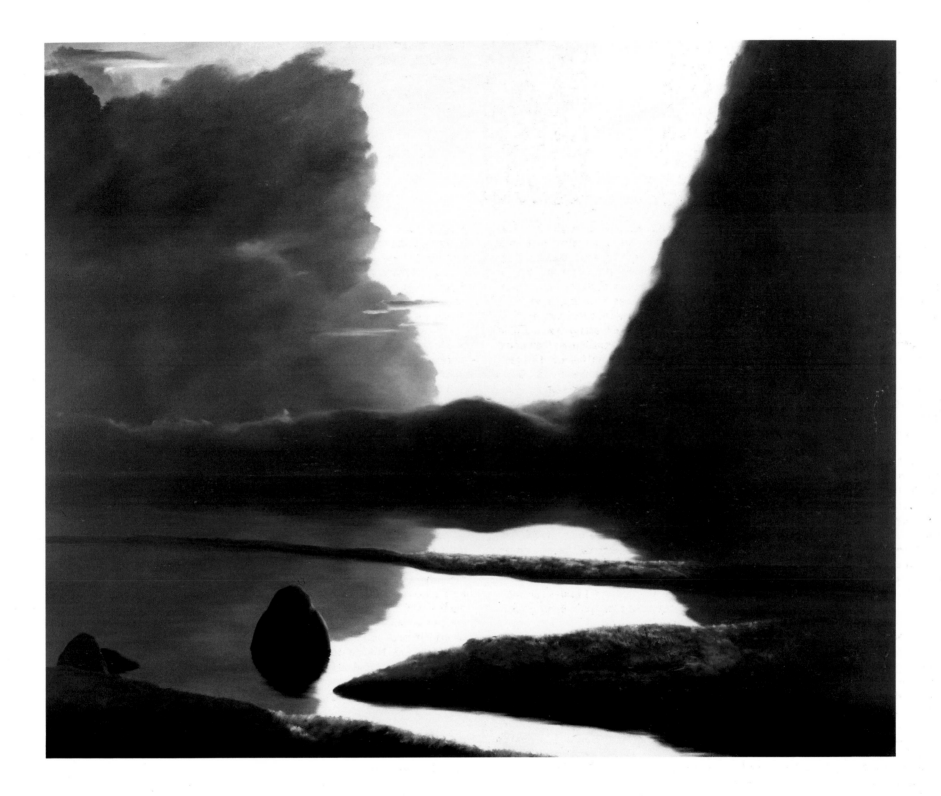

April Gornik

Corridor. 1984

Oil on canvas
74 x 95 in
Collection of Frederick and Jan Mayer

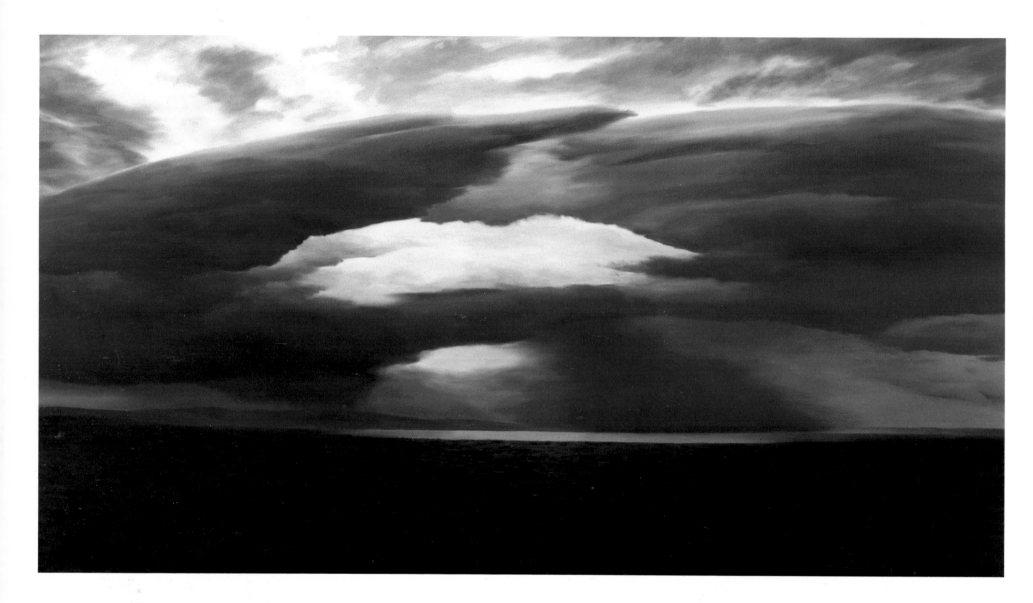

April Gornik

Storm Center. 1984

Oil on canvas
66 x 120 in
Collection of Laura Carpenter

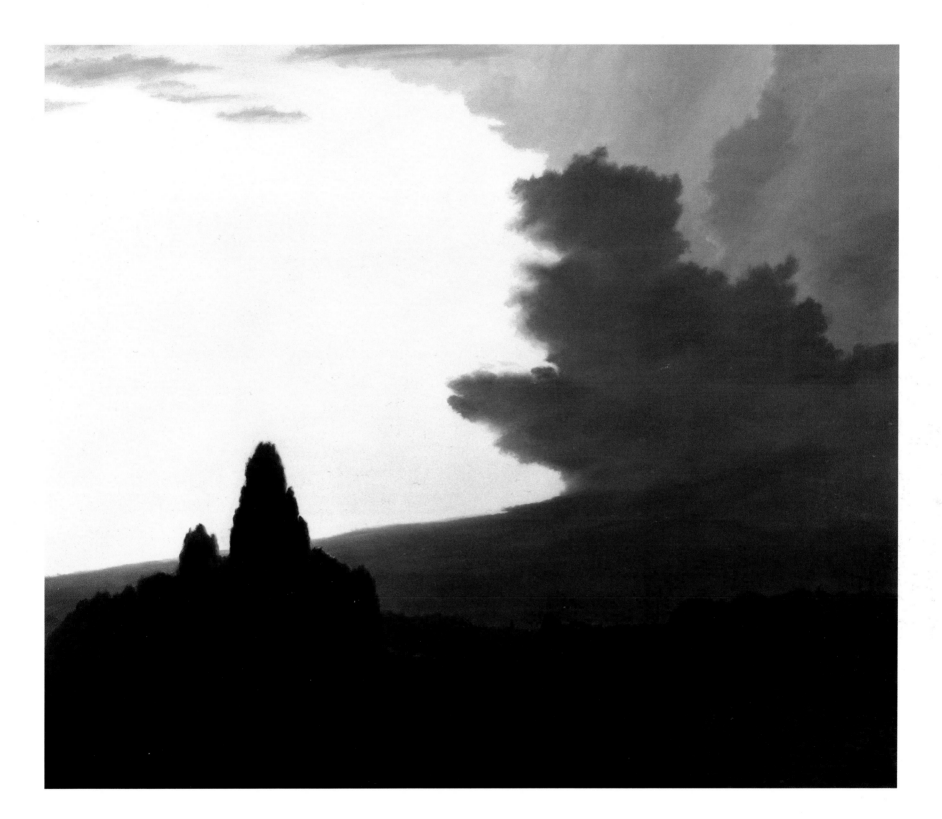

April Gornik

Divided Sky. 1983

Oil on canvas
72 x 85 in

Archer M. Huntington Art Gallery, University of Texas
at Austin, Gift of Mr. and Mrs. Jack Herring, 1984

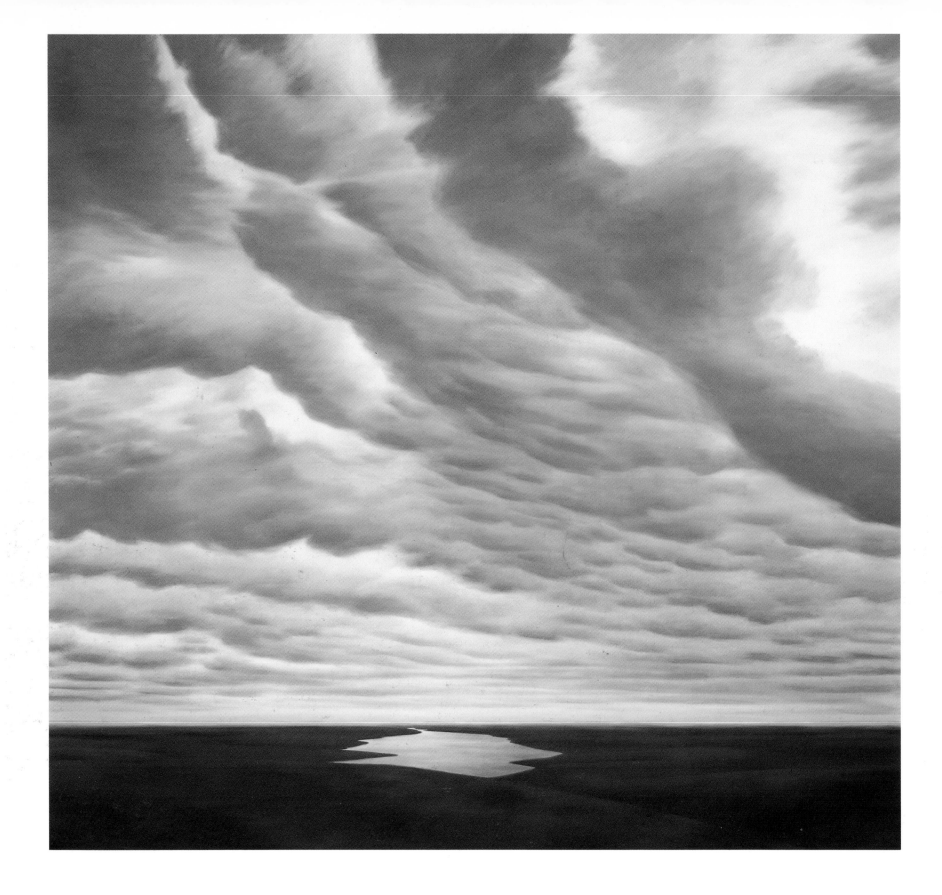

April Gornik

Cloud Wall. 1983

Oil on canvas
84 x 90 in
Collection of Helen R. Runnells

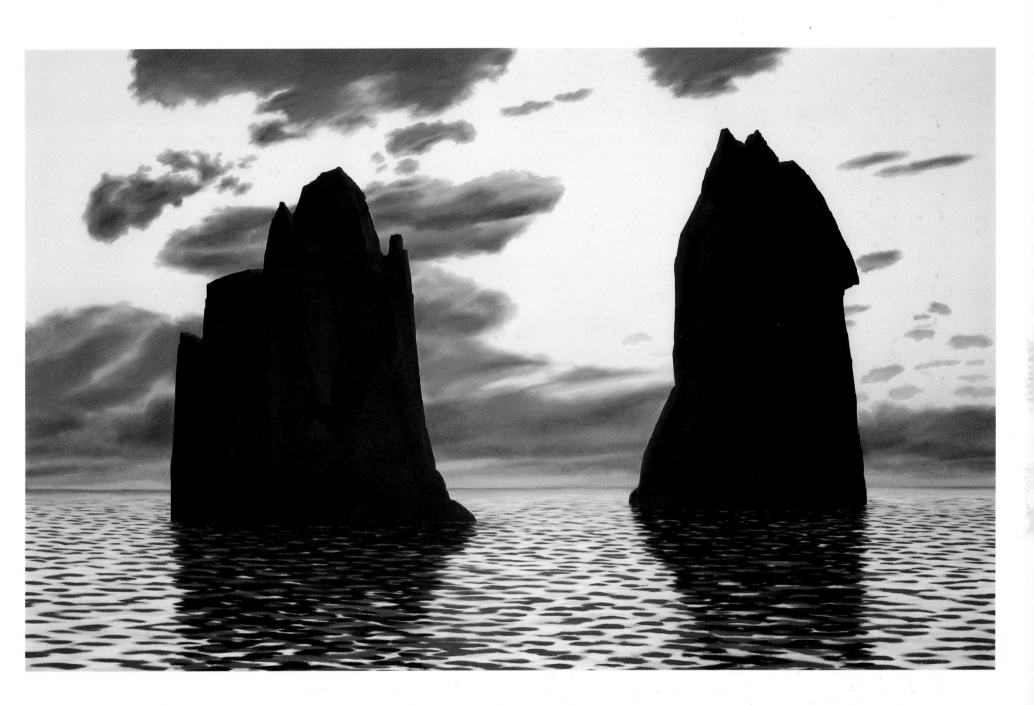

April Gornik

Equator. 1983

Oil on canvas
74 x 116 in
Collection of Laura Carpenter

Martha Alf

1930 Born, August 13, Berkeley, California

1952 B.A., Clinical Psychology, San Diego State College, San Diego, California

1963 M.A., Art, San Diego State College

1970 M.F.A., University of California, Los Angeles, California

Lives and works in San Diego, California

"Realism is important to me as an attitude reflecting my belief that the careful contemplation of the visual world is in itself an important philosophical act whereby the essence of inner things, or a kind of ultimate truth, is revealed through outer appearance."*

Martha Alf looks at things closely; and, she is nearsighted. She has been known to spend 20 minutes or so in the early morning contemplating the view out her window before she puts her contact lenses in. "The resulting blurred view," she says, "is full of magic." Those of us who are nearsighted know that the world can seem a soft interplay of light and dark planes, but Martha Alf's artistic vision further reflects a deeply inquisitive mind that sees whole worlds in small places.

When she was two years old, her family moved from San Diego to live with her grandparents in Winterset, Iowa, where they remained for six years. Martha recalls spending "hours on end" gazing at her grandmother's china collection, which was displayed in a cupboard behind glass. After they returned to San Diego, the family lived in the Hillcrest area, and Martha would play in its rugged canyons with her friends. The Southern California canyons are self-contained environments that seem to exist strictly for the wonder of children. Normally dry, the brown and golden grasses shimmer with sunlight; yet, a rare rain can transform them overnight into lush areas full of wildflowers. It was here that Alf's interest in landscape was formed, and ultimately this fused with her early memories of those untouchable objects to produce still lifes that often allude to landscape.

Alf entered San Diego State College in 1948 as an art major, but changed to clinical psychology at the end of her freshman year. The art classes were uninspiring, and the fact that each teacher presented a conflicting point of view meant that Alf spent a great deal of time "correcting 'mistakes'" that she had learned in a previous class. Her logical mind appreciated how the psychology classes built on each other, as well as the active exchange of ideas. During her junior year, she married fellow psychology student Edward Franklin Alf, who is now a Professor of Psychology at San Diego State. Soon after they were married, they lived in Seattle for six years while Edward earned his doctorate, and Martha recalls the awesome

quality of "that magic mountain," Rainier, and would later draw on such associations of monumentality for her artwork.

Upon returning to San Diego, she decided to pursue art at the encouragement of San Diego State faculty member, Everett Gee Jackson. The fact that in 1959 San Diego was rather removed from the mainstream of contemporary art meant that Alf could, to a very real extent, develop her own style, and at her own pace. At one point she was allowed to paint one still life for an entire semester, which may have, as Suzanne Muchnic points out, "cultivated her proclivity for seeing endless possibilities in a single subject and for working in series."

After receiving her M.A., Alf began seriously studying other artists, and she would continue to do so, sometimes for the purpose of teaching and writing. San Diego's art resources were negligible, and when even regular trips to Los Angeles museums and galleries proved limiting, she traveled on to New York and Washington, D.C., where she saw the power of the old masters' use of chiaroscuro for the first time. It soon dawned on her that all these artists were men, and she embarked on a course of study that reflects both her intensely logical mind and her investigative curiosity. During the years 1965-68 she undertook self-directed research of mostly obscure women artists, in part to determine whether it was even genetically feasible for a woman to be an artist. As recently as twenty years ago, this was a topic of discussion. She gathered enough information for a healthy book, but it was hardly marketable at the time. It fulfilled its purpose, however: she realized that persistence was the single greatest attribute for an aspiring artist, especially a woman.

Feeling the need for a more lively community, Alf moved to Los Angeles and enrolled in the UCLA graduate school in 1968. Teachers like Richard Diebenkorn encouraged her to explore abstraction, which she did, but she also continued to work on still lifes of objects she found in junk stores. Pop Art was helpful to Alf, as it was to so many artists at the time, because with it representation returned to art. At the same time, the women's movement in Los Angeles—with Judy Chicago, Miriam Shapiro, Dextra Frankel, Jessica Jacobs and others—

was causing quite a stir. This was very important in many ways, and June Wayne became Alf's first real role model as an artist. But Alf had already come to grips with so much on her own that it was difficult for her to join the group. Even though she feels very strongly about the issues and the value of the movement, she also believes deeply that art is beyond gender, that it is primarily a process of self-discovery and ultimately is a matter of visual and spatial concerns. It should be noted, however, that the women's art movement encouraged the exploration of highly personal content, which Alf certainly has.

One day in 1970, she was struck by the way light fell across some spray deodorant caps, and she began the rarified still lifes that soon led to her paintings of toilet paper rolls. Her first reaction to the subject was, "I can't do that," yet she liked the irony of these monumental "cylinders" almost as much as the pristine form itself. Besides, no one was really paying much attention to her work, so it didn't seem to matter what she chose to paint. As it turned out, these became benchmark pieces, and were included in the 1975 Whitney Biennial.

Her open acceptance of a chance sighting provoked the current work as well. While working on one of the cylinder paintings, she happened to notice how similar the quality of light was on three pears on her kitchen counter, and drawing after drawing followed. The fruits and vegetables may seem more anthropomorphic than the subjects of her earlier works, and have been said to hark back to her training in psychology in the sense that the edible objects refer to individuals or groups. But while it is true that the raked light enhances drama, and the colors create a mood, according to Alf these are essentially pure compositions that contain no such allusions. Observation is its own reward, and drawing actually trains the vision.

Alf began using photographs in 1975 to record the pears before they spoiled, and she now considers photography her second art form. Aside from the old masters, particularly Vermeer, she has come to feel her closest artistic kinship with such photographers as Imogen Cunningham and Julia Margaret Cameron. Alf begins her drawings by outlining the initial shapes from a projected photograph and then completes the drawing freehand. Since 1981, her photographic starting points have been black and white, so the color in the drawings is almost arbitrary, "one color suggesting another with no preconceived idea of how the result would look." With no guide from the real world, she "never knew when a work was complete…. Rather than staying with one drawing until it was completed, I would often have as many as ten in different stages. Each day I would look at them and if one said, 'Do this to me,' I would. But if none did, I would start another."

The Alfs own a Victorian house in Venice, California, and she and her husband spend most weekends there, largely to keep in touch with goings-on in the art world. Her primary residence is the house near San Diego State. Her studio is in an upstairs addition that has large windows on all four walls, so light spills in from all sides. She works mostly on the floor, wherever the light is best: "Light passing through creates my subject."

*This and all other quotes from the artist are drawn from written statements she provided, conversations with her or are quoted in Suzanne Muchnic's essay in *Martha Alf,* exh. cat. (Los Angeles: Fellows of Contemporary Art, Los Angeles, and Los Angeles Municipal Art Gallery, 1984).

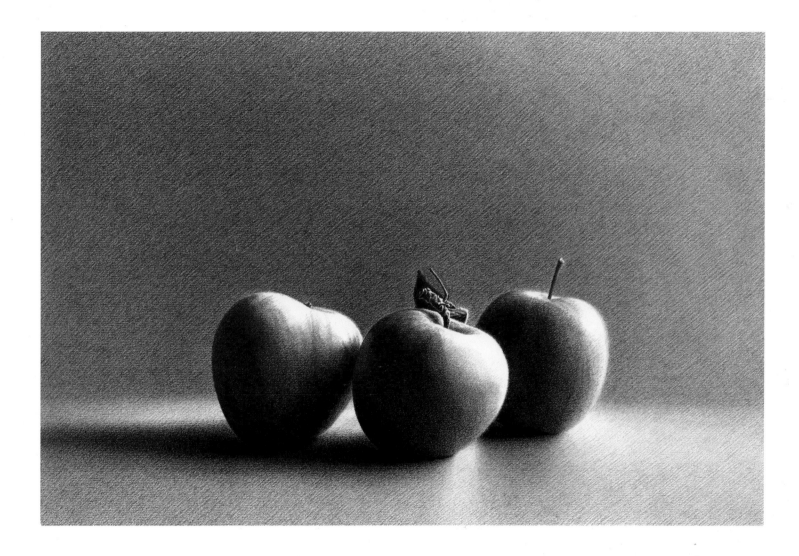

Martha Alf

Three Apples. 1980

Pencil on bond paper
12 x 18 in
Collection of Frank M. Finck, M.D.

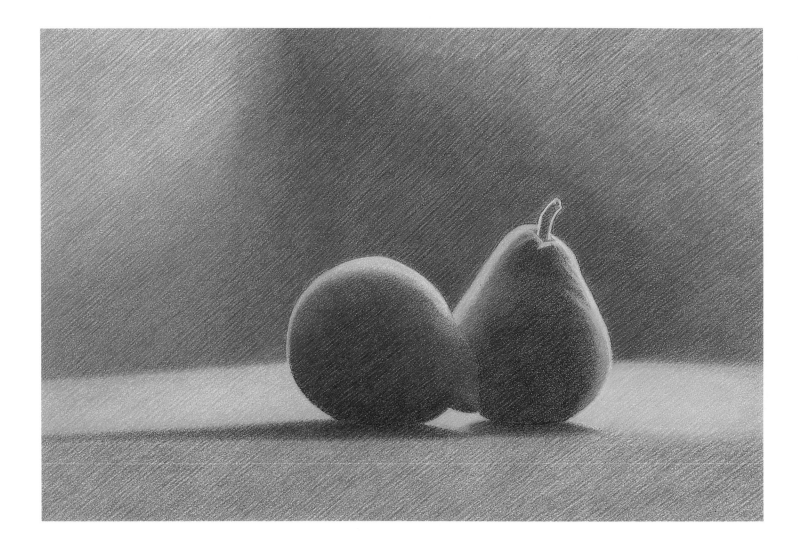

Martha Alf *Two Pears No. 3 (for Michael Blankfort).* 1982

Pastel pencil on paper
12 x 18 in
Collection of Alan S. Hergott

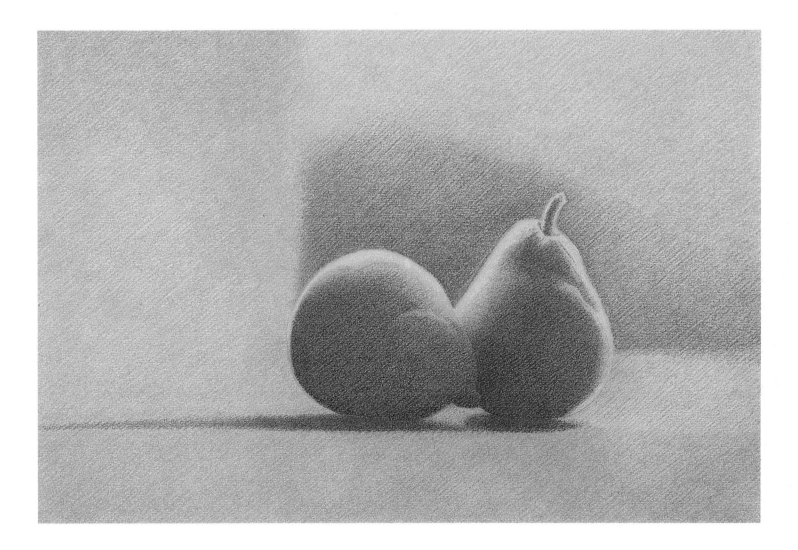

Martha Alf

Two Pears No. 6. 1983

Pastel pencil on bond paper
12 x 18 in
Courtesy of the artist and Newspace Gallery, Los Angeles

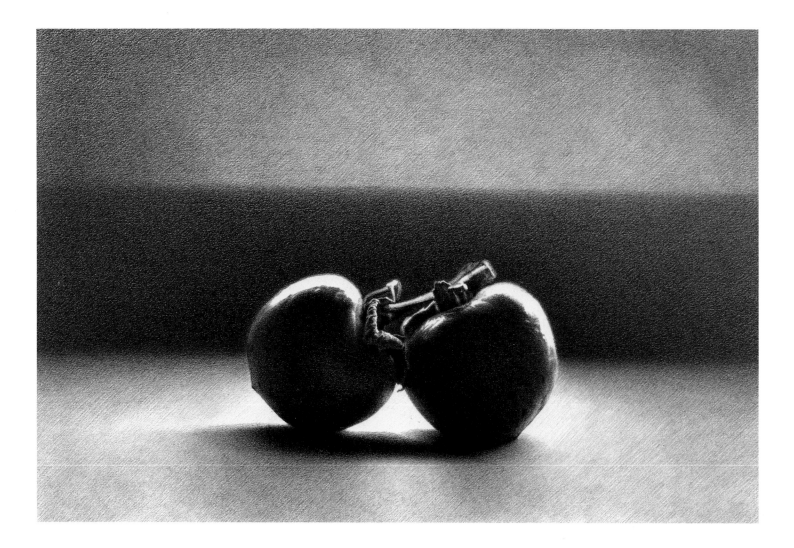

Martha Alf	*Persimmons No. 3.* 1978

Pencil on bond paper
12 x 18 in
Collection of O'Melveny and Myers

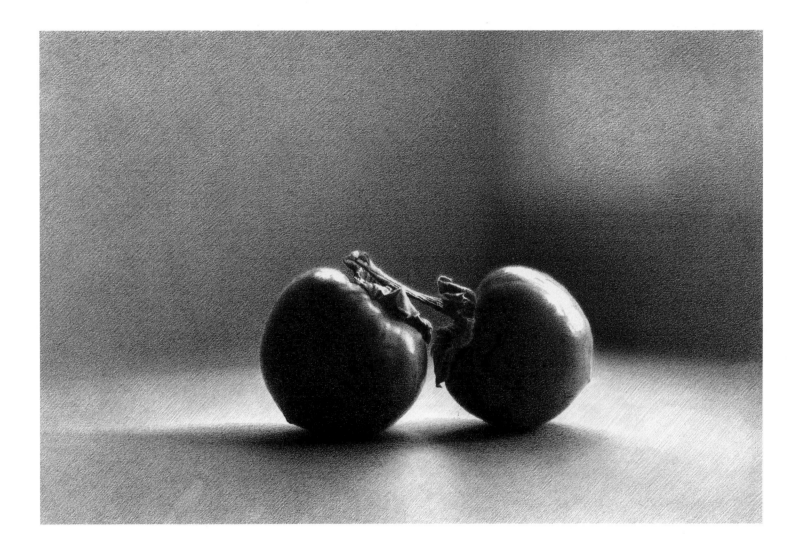

Martha Alf

Persimmons No. 2. 1978

Pencil on bond paper
12 x 18 in
Private Collection

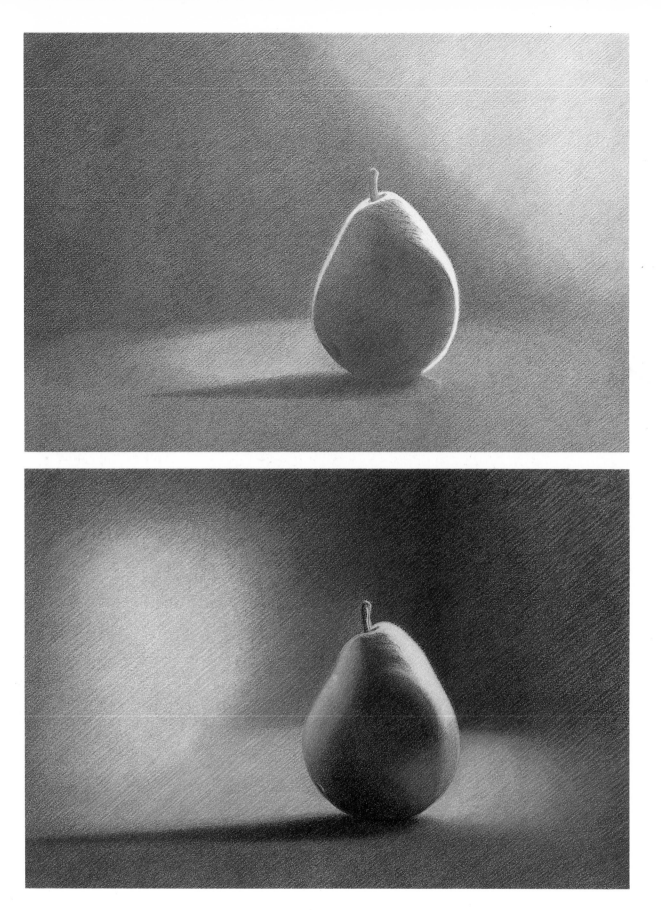

Martha Alf

Pear No. 20. 1983

Pastel pencil on paper
12 x 18 in
Courtesy of the artist and Newspace Gallery, Los Angeles

Pear No. 6. 1982

Pastel pencil on paper
12 x 18 in
Courtesy of the artist and Newspace Gallery, Los Angeles

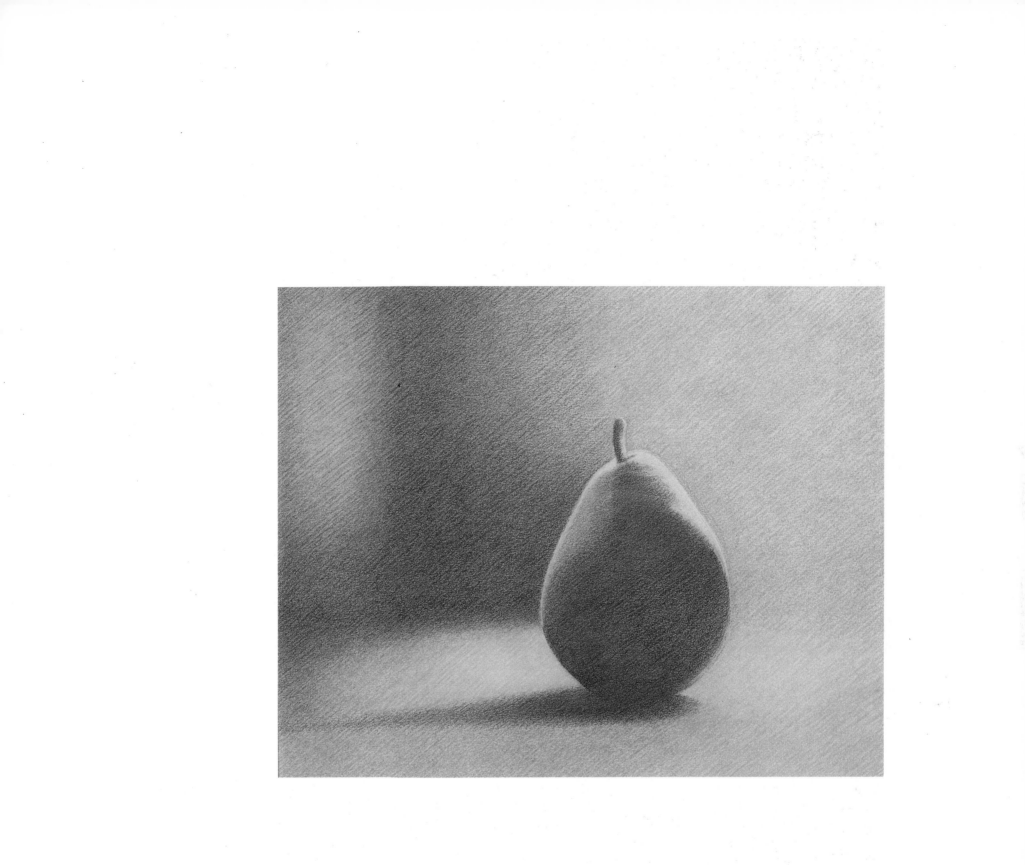

Martha Alf

Pear No. 13. 1981

Pastel pencil on bond paper
11 x 14 in
Collection of R.K. Benites

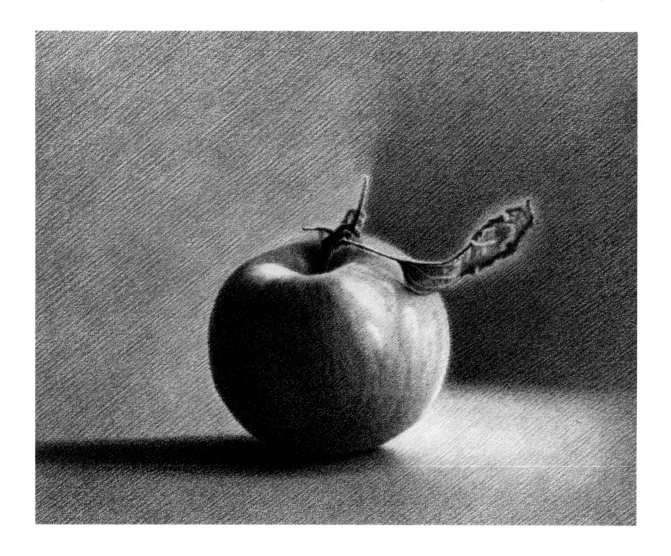

Martha Alf *Apple No. 7.* 1980
Pencil on bond paper
11 x 14 in
Collection of the artist

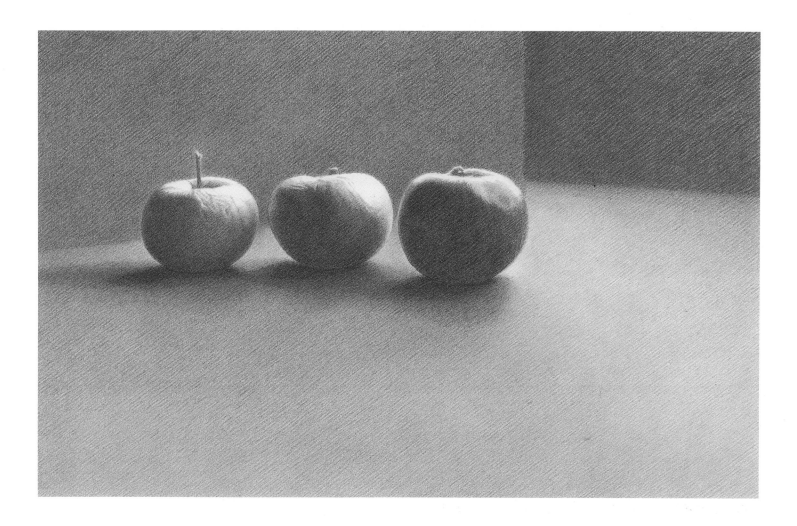

Martha Alf

Three Crabapples. 1984

Pastel pencil on bristol vellum paper
14 x 22 in
Courtesy of the artist and Newspace Gallery, Los Angeles

Norman Lundin

1938 Born, December 1, Los Angeles, California

1961 B.F.A., School of the Art Institute of Chicago, Chicago, Illinois
1963 M.F.A., University of Cincinnati, Cincinnati, Ohio

Lives and works in Seattle, Washington
Teaches at the University of Washington, Seattle

"Just as you cannot have a 'long' without a 'short' for comparison, you cannot have a 'void' without an object. It is the void that interests me."*

The soft light that filters through Norman Lundin's cool interiors seems a fitting expression for a Seattle artist of Scandinavian ancestry. Lundin grew up in Chicago, knowing he wanted to become an artist; he went to the School of the Art Institute at the same time as Ed Paschke. Although they never took a class together, both received an education that stressed Abstract Expressionism and calling on one's inner resources rather than referring to objective reality. Lundin was successful with this approach, and his current work—though extremely naturalistic—is also drawn from the mind's eye.

When Lundin was offered a full scholarship for graduate study at the University of Cincinnati, its acceptance was an easy choice, since he had a family to support. Abstraction was still the rule of the day, and he evolved his palette of grey, blue and orange then. By the time of his thesis, however, his work was completely figurative. Abstraction and working strictly on the picture plane were too limiting, and he was becoming more interested in illusion, both intellectually and as a tradition. After graduation, he took a job at the Cincinnati Art Museum designing and reconstructing two 12th-century Spanish Romanesque rooms: it is tempting to associate this with his present paintings and drawings of interiors, but he plays down any such specific effect on his art. Even though the drawings are successful in part because Lundin is a fine carpenter who understands architectural spaces, they draw on something more ephemeral.

As a student Lundin became interested in Edvard Munch, and a Fulbright Fellowship allowed him the opportunity to go to Oslo and study the great Symbolist painter. It was there at the National Gallery that he first saw Munch's 1889 painting *Spring*: its composition and stunning use of light stopped him cold. To this day, he still shows a slide of it to all his classes. In addition to the influence of Norway's light, he was exposed to the work of Strindberg and Ingmar Bergman, and they also had much to

do with confirming his coolly expressionistic sensibility. Lundin readily makes associations between drama and the plastic arts; he draws a clear distinction between good realism, which calls on dramatic possibilities, and mere reportage. He feels the artist's job in composing a picture is much the same as the dramatist's job in writing dialogue, for both must edit and heighten a given reality.

Lundin's fellowship ended in 1964, and he received job offers to teach in Tasmania and in Seattle. He had never been to either place, but chose the University of Washington and has been there ever since. He joined a faculty centered around abstraction, and while his natural predisposition for an expressionistic realism did not fit in, his work did find an audience. It was the time of the social orientation and humanitarian feelings that revolved around the unrest over the Vietnam war, and Lundin's work became its most overtly expressionistic. The howling dogs and hanging men recalled the work of Munch at his most anxious, and were included in the landmark Whitney show of 1969, "Human Concern."

One might say that the ghost of Munch's expressionism was exorcised, for Lundin began to feel that the subject matter was doing too much of the work. He wanted to neutralize the strong content "so that the viewer wouldn't bring so much baggage along in seeing the art," and wanted to prove his ability to be expressive in a less obvious manner, the appreciation of which would be based on contemplation rather than the viewer's immediate reaction to the subject.

Teaching gave Lundin the opportunity to work on his technical skills, and he really began to "educate his hand" in 1964 when he began at the University. He feels that teaching has gone a long way towards putting his own house in order, clarifying his direction and ideas. He cautions against mistaking the striving for success for real involvement and emphasizes working on technique and form: "Interpretation and expression are about the only things that count. But if you want to be a piano player, you better know how to play the piano."

Home is, in many ways, an efficient and comfortable stopping place, for Lundin loves to

travel, and a show in Dallas, for example, is an excuse to drive by way of Cincinnati or Los Angeles. The studio/residence is as compact and intimate as a boat. It is located in an upstairs apartment the artist crafted for himself in a 1920s house overlooking Seattle's beautiful Green Lake. He doesn't require much room, and lives simply; draws upstairs, paints in the basement. While he has had a number of studios in Seattle as well as temporary ones in places as far away as New York and London, his art is not dependent on location. And though the titles of recent works refer to such specific places as "60th Street Studio," they show spaces of the mind, memories of many places if not purely imaginary ones. The actual 60th Street studio is a small, neat room just off the kitchen.

Lundin begins by making quick notebook sketches as a shorthand method to state an idea, and then goes right to the work itself. People often ask to see the studio, the drawings within the drawings, or the objects that serve to define the spaces or show the play of light—but, of course, there are none. It is in part due to Lundin's interest in literature that he has the sophistication to understand how compelling illusion is, and that a play within a play focuses attention. But it is his ability to draw that makes the illusion so complete. Norman Lundin intends his drawings to be stages set to dramatize absence, and for light to be "the pusher, the mover, the weight" that informs the void.

*All quotes come from conversations with the artist and a written statement he prepared (January 1985).

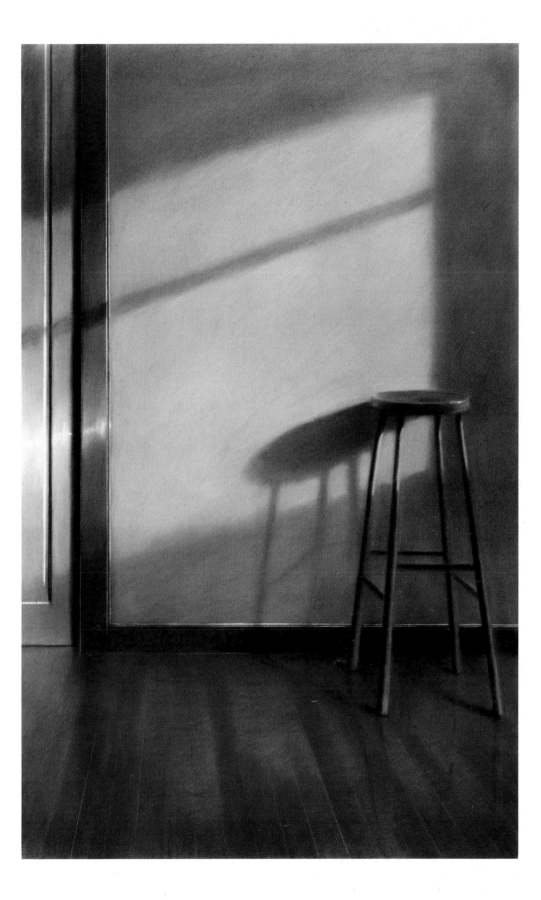

Norman Lundin

60th St. Studio: Drafting Stool. 1984

Pastel on paper
44 x 28 in

Courtesy of the artist and Allport Associates Gallery,
San Francisco

Norman Lundin

Studio Blackboard. 1984

Pastel on paper
28 x 44 in
Collection of The Southland Corporation, Dallas

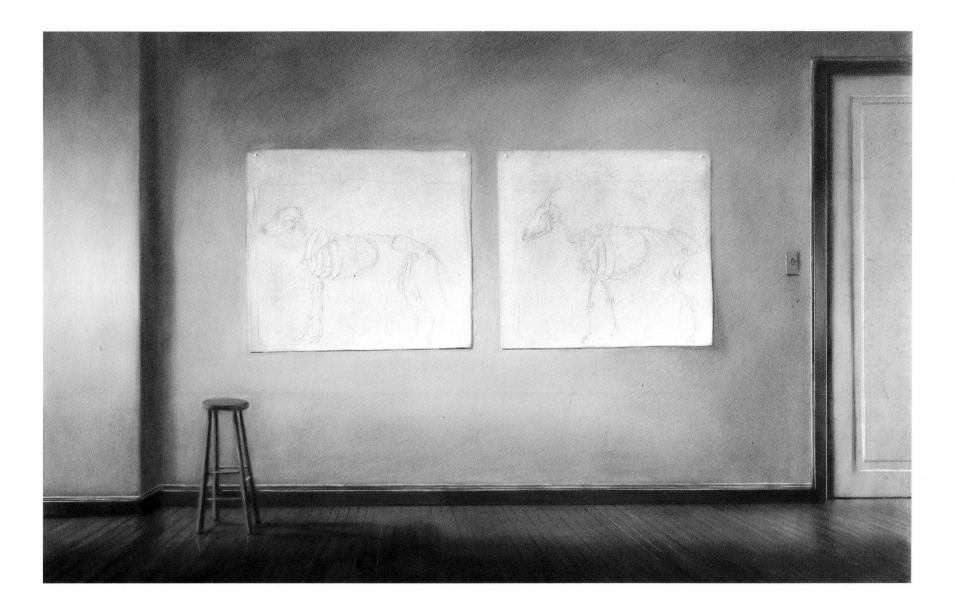

Norman Lundin

Studio: Two Drawings and a Red Stool. 1984

Pastel on paper
28 x 44 in
Collection of Dr. Alvin Martin

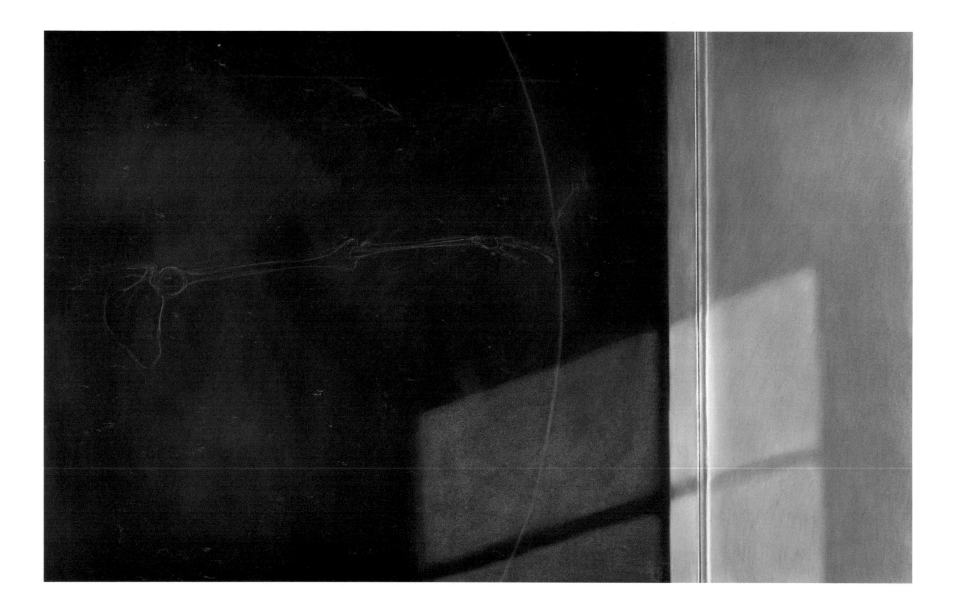

Norman Lundin

San Antonio Anatomy Lesson. 1982

Pastel and charcoal on paper
28 x 44 in
Courtesy of the artist and Space Gallery, Los Angeles

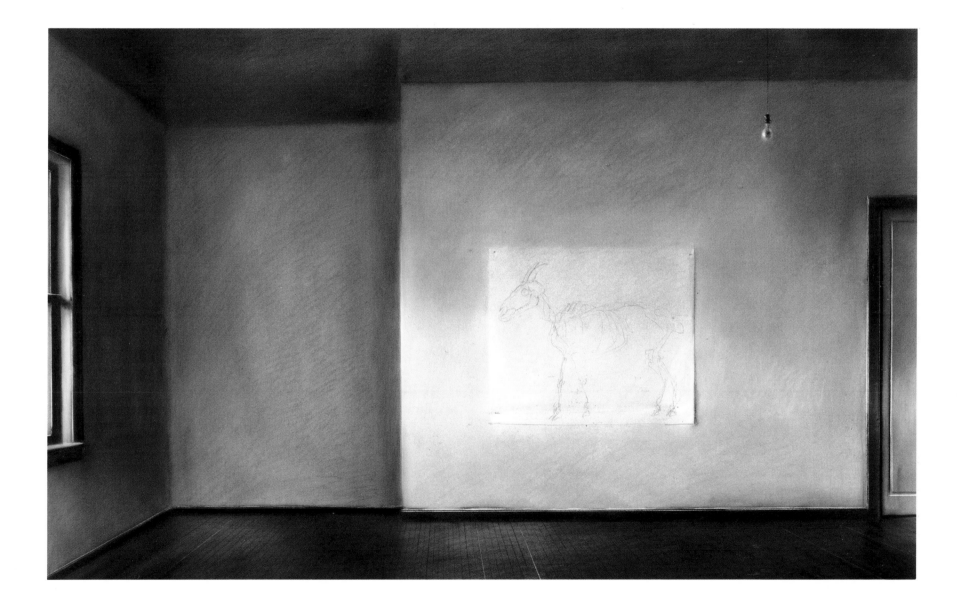

Norman Lundin

Studio: Drawing of a Goat, No. 2. 1983

Pastel on paper
28 x 44 in
Collection of Karl K. Ichida

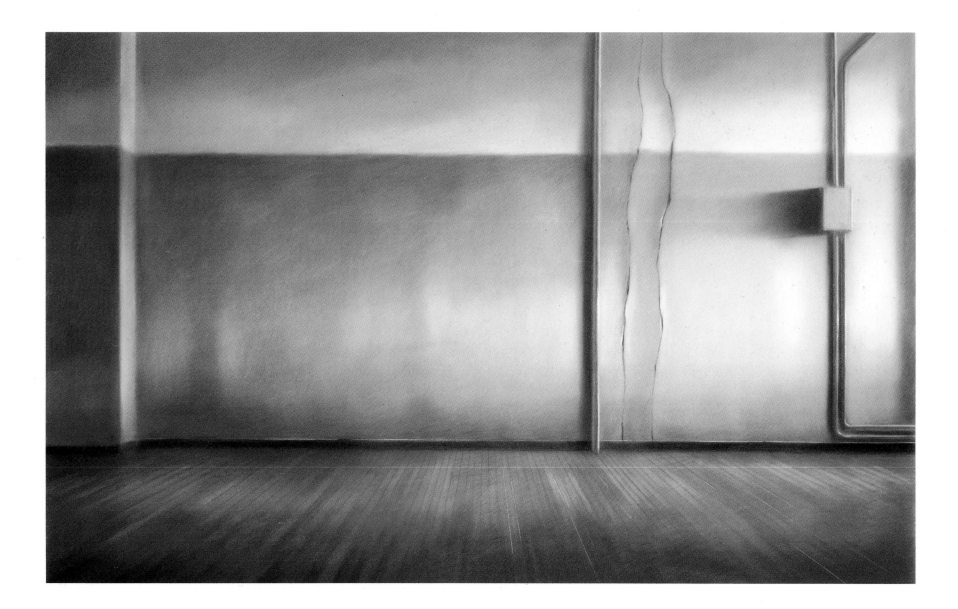

Norman Lundin

60th St. Studio: South Loading Dock. 1984

Pastel on paper
28 x 44 in
Corson/Davis Collection

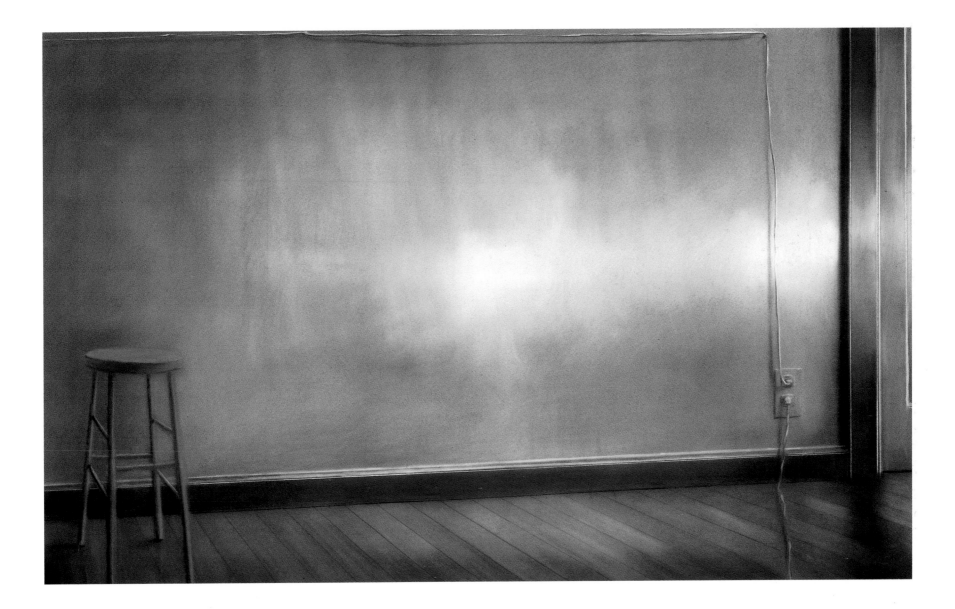

Norman Lundin

Sunset Hotel No. 2. 1984-85

Pastel on paper
28 x 44 in
Courtesy of the artist and Francine Seders Gallery, Seattle

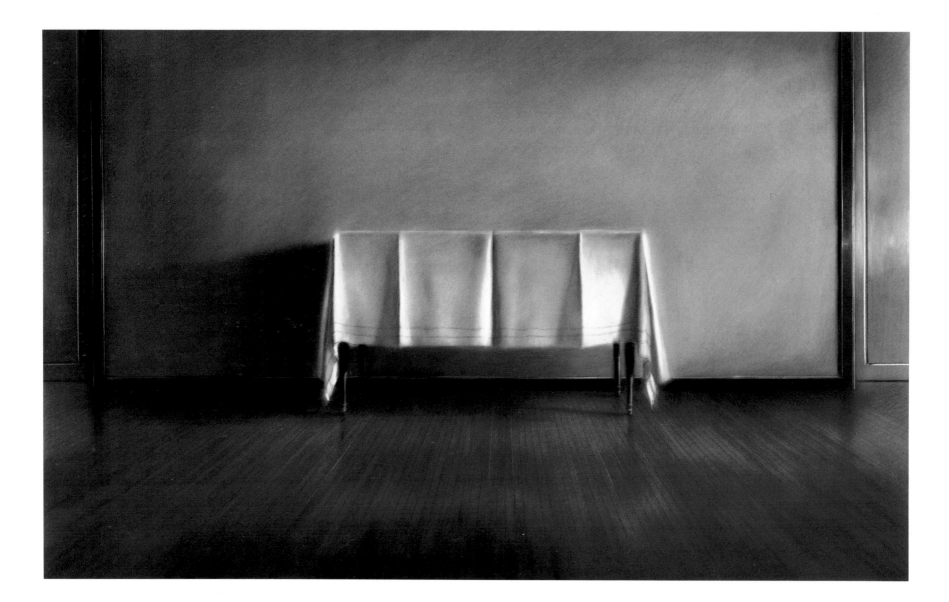

Norman Lundin

60th St. Studio: White Tablecloth. 1983

Pastel on paper
28 x 44 in
Courtesy of the artist and Francine Seders Gallery, Seattle

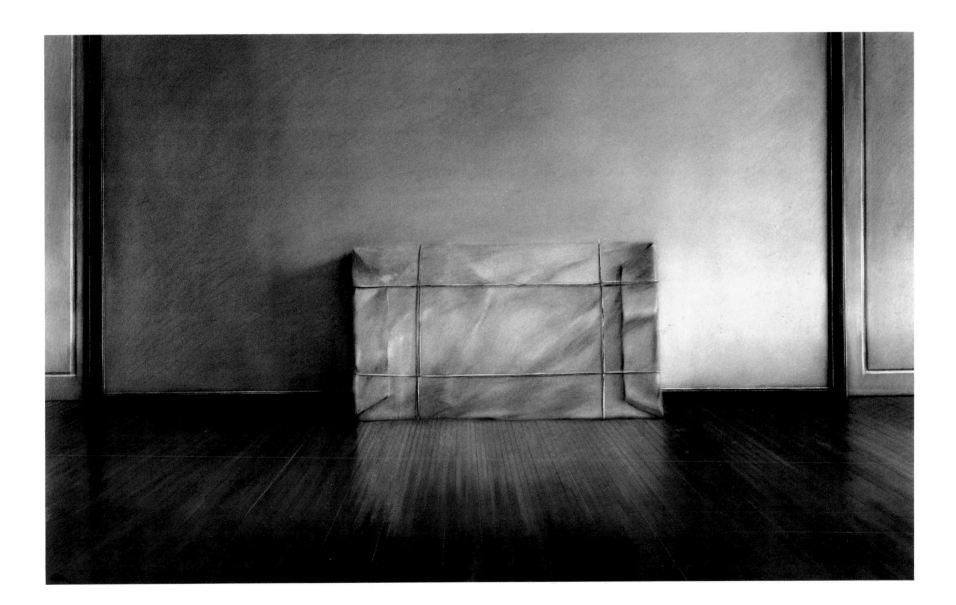

Norman Lundin

60th St. Studio: Wrapped Package. 1983

Pastel on paper
27 x 43 in
Collection of Riddell, Williams, Bullitt & Walkinshaw

Ed Paschke

1939 Born, June 22, Chicago, Illinois

1961 B.F.A., School of the Art Institute of Chicago, Chicago, Illinois

1970 M.F.A., School of the Art Institute of Chicago

Lives and works in Evanston, Illinois
Teaches at Northwestern University, Evanston

"Perception—what we experience through our sensory apparatus—is being affected by the rapid acceleration of media-related technology…. For me, the distinction between direct experiences and those which are modified through mass media is becoming smaller and smaller."*

Ed Paschke looks at the way mass media describes the world. A rather private person even as a youngster, radio became the primary point of departure for his imagination. It would spark a stream of mental pictures, and this fascination has persisted. Paschke's recent work reflects his opinion that movies and TV have a great deal to do with how we define the world we inhabit as well as how we see ourselves. The reference to electronic impulses is more than an observation about our media-engulfed, high-tech society, however. It also has to do with something more illusive—an intimate, psycho-electrical-chemical process through which we gather information. The paintings are, as John Yau has said, of "bodies and faces [that] look like neon electro-cardiograms"; Paschke states that "my theory was and still is that the viewer more or less completes the circuit like electronic energy." Paschke is the transmitter from unknown worlds, a person who is fascinated with how mass media presents reality, and the way we receive that information and assimilate it.

Going to art school was initially a rather confusing experience for an introspective young man right out of high school. He was faced with a pervasively Abstract Expressionist attitude toward art (which Norman Lundin also encountered at the Art Institute during the same period, 1958-61), but Paschke would go home at night and work on drawing realistically. He finished his B.F.A. feeling that some of the basics of picture-making had begun to jell for him, and feeling certain that no one on the outside really cared whether he made art or not. In a way, this awareness allowed him some freedom, and his curiosity led him to a job as a psychiatric aide in a mental hospital "to find out what happens within the confines of those walls…. To this day, I still draw on that experience from time to time," he says. A stint in the military followed, which took him to rural America for the first time. After Chicago, it was like being in a

foreign land, and Paschke discovered how very different people could be—in spite of what he presumed was the total pervasiveness of the mass media. And it is his ability to present personalities who are so outside our normal experience combined with the intimate relationship we have with the media that makes his work so intriguing.

After leaving the military he traveled to Europe, and then sojourned in New York. It was 1964, and Pop Art was in its heyday. It had a liberating influence on Paschke's work and helped confirm his natural predisposition toward representation with mass culture overtones. He began a series of small collages using black-and-white media images that he would often paint over, works that he says have been very much the basis of everything he has done since in that he still begins with ambiguous, media-derived images.

Paschke returned to Chicago in 1965 and set up a studio where he loaded the walls with all the images he could find, looking at them "as a kind of psychic resource." The spirit of psychedelia was in the air, and it gave a sense of release to Paschke. At the time, much attention was being given to rock music, black lights and dayglo, light shows, social confrontation, a fascination with the disenfranchised, and an interest in a heightened reality beyond the established daily routine. Paschke painted nocturnal urban creatures bathed in electronic light who seem to inhabit a world that would just dissolve with the normal light of day. At the same time, a number of artists—many associated with the Art Institute—began to coalesce around the excitement created by Don Baum's group shows at the Hyde Park Art Center on Chicago's south side. The shows were happenings in themselves. Groups of artists assumed provocative names like rock bands: Hairy Who, The Nonplussed Some (which included Paschke), False Image (with Roger Brown). Paschke confesses to having "felt like an orphan in the sense that everyone else seemed to share an enthusiasm for a lot of the same concerns," and this seems to have combined with an easygoing, natural sense of detachment. But the atmosphere was undeniably supportive, and a number of very talented

artists were given an opportunity to be seen. In fact, partly due to the attention paid to Hyde Park, by the time Paschke finished his M.F.A. he had already been included in shows at Chicago's Museum of Contemporary Art and at the Whitney Museum in New York. (Again, he and Lundin unknowingly crossed paths, as participants in the 1969 Whitney show, "Human Concern.")

Paschke is very much an urban artist, and he retains his Chicago roots. His studios have been in the same business district for over a decade (currently in an old two-story office building; before that, down the street above the movie theater). The El rumbles by, and empty storefronts are not uncommon. Two blocks away is "the jungle," an area well-known for drug-trafficking until it was recently cleaned up.

In contrast to his studio environment, Paschke teaches at nearby Northwestern University, a private school in the upper-class North Shore community of Evanston. But even on a teaching day, he will be at the studio early; there is always work in progress and painting remains his passion. He is a thoughtful man, and one senses that he is a quietly inspirational teacher. He speaks of the satisfaction of touching a younger person's life in a meaningful way. He stresses a broad foundation and a mind open to the influences of one's time and place. Of paramount importance to him is a deep belief in being an artist, in accepting a life of exploration and commitment to one's craft and personal vision.

Paschke begins his paintings by projecting a photographic image from a media source to set some initial formal elements, and then paints a black-and-white underpainting. Transparent layers of color are applied, and ultimately specific lines and highlights are built up. All oil on canvas, with brushes. He retains his role as translator, and enjoys the fact that

these electrically-charged portraits are done with such traditional methods. He is fascinated by the transformation of the source material: "To clarify the process, consider the sequence: object—photo of object—reproduction of photo—individual's translation of the reproduction."

The paintings in this show were produced during a time (1979-82) when a concern for video-like electronic energy became very interesting to him, partly as a means to generalize and universalize his figures: they are no longer specific urban outsiders. The faces and clothing have vaporized. Paschke began looking at television at this time to observe how it was put together: the static, the "snow," the ghosting glows, the way the horizontal lines compose the picture. He gives this background: "I think maybe there is something involved there with computer technology, with what they are doing with genetic construction of living organisms, radiation. All those kind of unnatural things. And it is important to me that there is a slightly unsettling quality about these things in the sense of humanity versus science." Ed Paschke's paintings may embody a kind of personal scientific fiction, but they are familiar: if you have a TV, you know these pictures.

*Ed Paschke, "Notes on a Work Process," Profile 3, no. 5 (September 1983), p. 29. Other quotes from the artist are drawn from Kate Horsfield's interview with him found in the same publication, a written statement he provided or conversations with him (November, December 1984).

Ed Paschke

Tres Artistique. 1981

Oil on canvas
19¾ x 42 in
Collection of Mr. and Mrs. Alexander C. Speyer III

Ed Paschke

Montaigne. 1979

Oil on canvas
36 x 102 in
Collection of Mr. and Mrs. Lawrence I. Aronson

Ed Paschke

Critique. 1981

Oil on canvas
42 x 70 in
Collection of Ed and Nancy Paschke

Ed Paschke

Waxworks. 1982

Oil on canvas
32 x 82 in
Collection of Continental Illinois National Bank
and Trust Company of Chicago

Ed Paschke

Embrasse. 1982

Oil on canvas
42 x 80 in
Private Collection

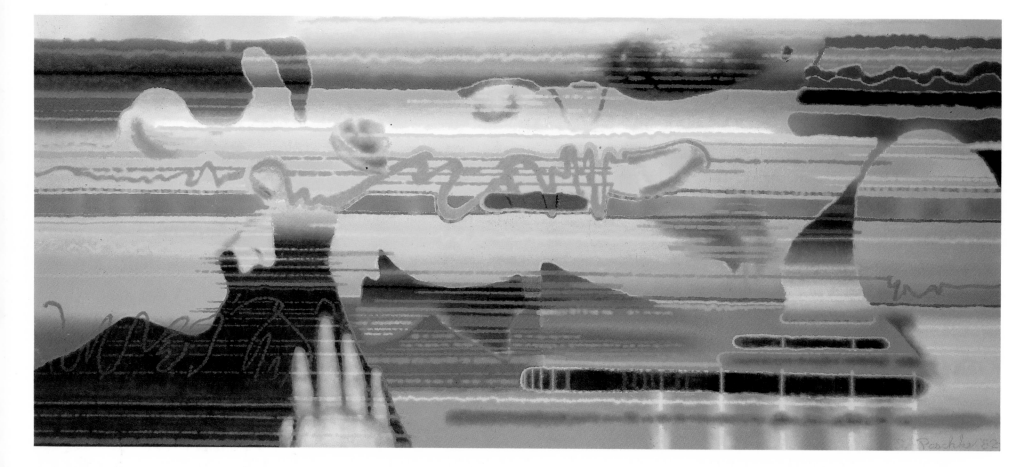

Ed Paschke

Elektroid. 1982

Oil on canvas
36 x 82 in
Stephen S. Alpert Family Trust

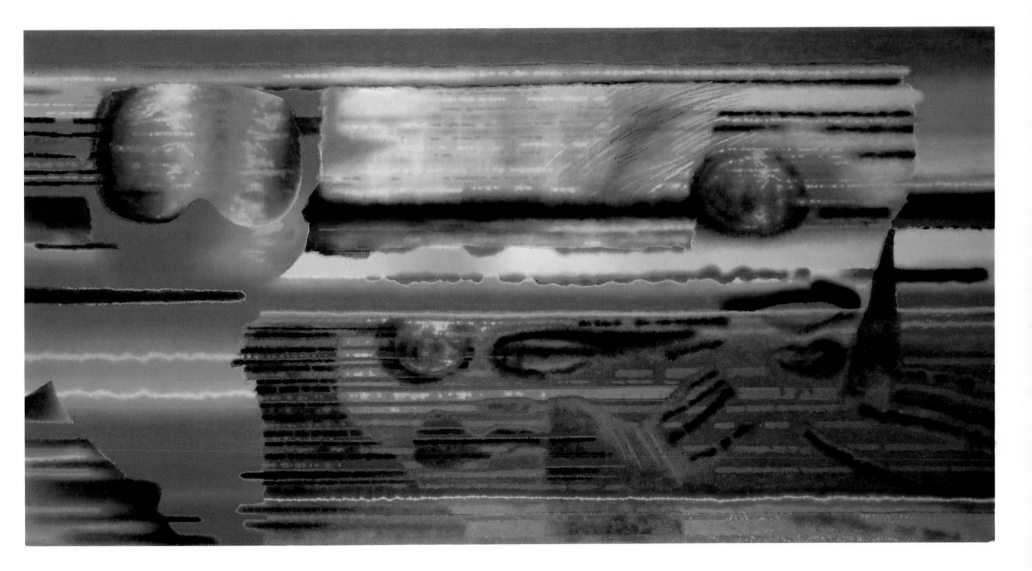

Ed Paschke

Pachuco. 1982

Oil on canvas
42¼ x 82 in
Private Collection

Roger Brown

1941 Born, December 10, Hamilton, Alabama

1968 B.F.A., School of the Art Institute of Chicago, Chicago, Illinois

1970 M.F.A., School of the Art Institute of Chicago

Lives and works in New Buffalo, Michigan, and Chicago, Illinois

"Painting, I believe, should come directly from life's experiences and one's personal responses, the mainstream and latest trends be damned."*

Roger Brown's paintings have an inner light, infused with memory and recollection even when the subject is a current event. Certainly, our strongest visual impressions are those that withstand time, and Brown recalls nighttime automobile trips when he was a child growing up in rural Alabama: "I would remember the route we drove to my grandmother's house by architectural signposts—a hamburger joint detailed in red and green neon, the skyscrapers of Birmingham, the towns, gas stations and bridges along the curving highway through north Alabama." It is clear that Brown's childhood laid a resonant foundation for his art, and even those paintings taken from his travels are aglow with that nostalgic light. But the direct artistic influences came largely during a decade's time in Chicago, where he moved in 1962.

The School of the Art Institute of Chicago has the advantage of being connected with a great museum, and while Brown was a student there, A. James Speyer was mounting shows that included Warhol, Lichtenstein, Oldenburg and Westermann, as well as exhibitions in which Brown first saw the work of Balthus and de Chirico. But while the museum presented the famous names, Brown was being shown other sides of art at the School. Art historian Whitney Halstead encouraged students to investigate tribal and oriental art. Ray Yoshida, an outstanding artist and teacher, was able to communicate the value of drawing on personal experience in bringing art and life closer together, and it was Yoshida, along with Hairy Who luminary Jim Nutt, who first came across the work of Chicago folk artist Joseph Yoakum. Yoakum began painting in 1962 at the age of 75 in response to a dream in which God commanded him to do so. Brown remembers that "it was like finding Rousseau in our own back yard." He called Yoakum one day in 1968, and it was not long before Brown and his friends began making regular visits and collecting Yoakum's work. In his delicately

outlined, organic landscapes he uses a motif of repeated patterning that influenced Brown's style, but as Russell Bowman observes, "Yoakum, like Westermann, was perhaps more important as an example of what an artist should be—someone working on his own inner urgings." Brown is to this day a great advocate and collector of folk and naive art.

Around this same time, artist Don Baum began organizing the succession of startling group shows at the Hyde Park Art Center that would change the course of art in Chicago. The first Hairy Who show was in 1966, and the flamboyance of their shows almost instantly brought the limelight to Hyde Park, which exhibited the Nonplussed Some the following year and then the False Image, of which Brown was a member. It should be remembered that Brown was still a student, and being asked by Baum to show at the Center was like a dream come true.

It was in the False Image show that Brown showed his "theater paintings"; one could say that in these 12x12 inch works art and life first came together in a way that tells us much about the very personal nature of Brown's art. These are rather tonal paintings in which the interior space is outlined and defined by simplified Art Deco prosceniums. Presented on stage are dramatically-lit, ambiguous situations: empty stairs, silhouetted figures looking at (or looking out from) a mountainous rock, a movie screen, etc. "I began to synthesize a simple direct technique with my interest in de Chirico, comic book styles, and the use of personal imagery from my own experience," said Brown about them. The theater format was inspired by visits he and fellow art students made to the old Clark Street Theater to view movie classics, and the paintings have something of a *film noire* look. The silhouetted figures with their 1940s clothing and hairstyles came from early memories of his parents. The pulsing bands of light relate very much to those nighttime family automobile trips, as well as memories of the movie theater in his hometown of Opelika, Alabama, which was built in the thirties and "had wonderful phosphorescent glows and Art Deco details." The theater format itself was abandoned later that year following a trip to the Southwest,

which rekindled an interest in landscape. But the ominous, dreamlike quality of the light and silhouettes of these early works have obviously remained key aspects of the artist's style.

After the theater paintings, Brown began a series based on Chicago neighborhoods and parks at night. It is interesting to note his early choice of *Chicago* neighborhoods, for Brown has become something of a champion for regional, i.e., non-New York mainstream, sources. He had read Robert Venturi's *Complexity and Contradiction in Architecture* (1966) as a student, which helped confirm his feelings about the value of American vernacular subject matter and of ambiguity. However, the former already seemed to be a personal preference, fundamental to his Southern roots and confirmed by his frequent travels.

Architecture and travel would continue to play a large role in Brown's life, particularly in the person of architect George Veronda, whom Brown met in 1972. Veronda introduced him to the subtleties of Mies van der Rohe's buildings and their influence on Chicago's skyline. The two would take excursions around the city, and Brown says that he "began to see for the first time the beauty and elegance in the details and the order in these buildings. I saw how these same underlying principles were important to painting as well." That new awareness of internal structure and spatial ordering is strongly evidenced in his work since 1972. The cityscapes obviously reflect these interests and influences, and the landscapes do too. In fact, *The Black Hills* (1984) is a moving homage to Veronda (who died last year) and a 1972 trip the two friends took to Veronda's boyhood home in the hills of South Dakota.

Brown has traveled regularly throughout North America and in Europe over the years, and each trip has generated paintings. He is

first and last an American artist, however, and deeply committed to his region, as *Lake Effect* (1980) so clearly demonstrates. His artistic vision is a distillation of what it is like to see his area of the country. Driving around Chicago, especially at night, is much like moving through a series of Roger Brown paintings.

A recent source of inspiration has been Brown's Veronda-designed house in the dunes near the southeastern shore of Lake Michigan. It is a very formal structure "placed among willows, cattails, and wildflowers overlooking a small river and expansive marsh", very open to the gentle, natural setting where migrating birds fly overhead. It is about as far removed as one could be from his secondary studio/residence in an older area of Chicago, and yet the two environments continue to feed his work in a very direct way. Roger Brown is an artist who allows himself to be deeply moved by a given place or event in the outside world. He has the ability to hold that experience within himself, take it to the studio, and then filter it through that dramatic light and unique style to create a very personal statement about the world in which he lives.

*From a written statement dated 1984, courtesy of the artist. All quotes from him are from this statement or one dated 1980, or his essay "Paintings and Recollections," in *Who Chicago?*, exh. cat. (Sunderland, England: Ceolfrith Gallery, Sunderland Arts Center, 1981), pp. 29-33.

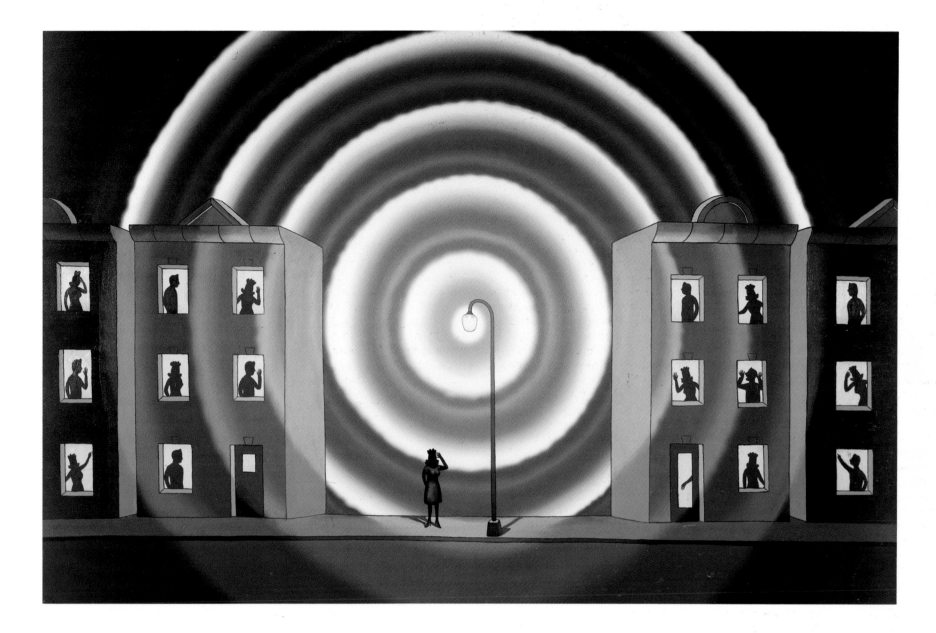

Roger Brown

Streetlight. 1983

Oil on canvas
48 x 72 in
Collection of Gregory and Lourine Clark

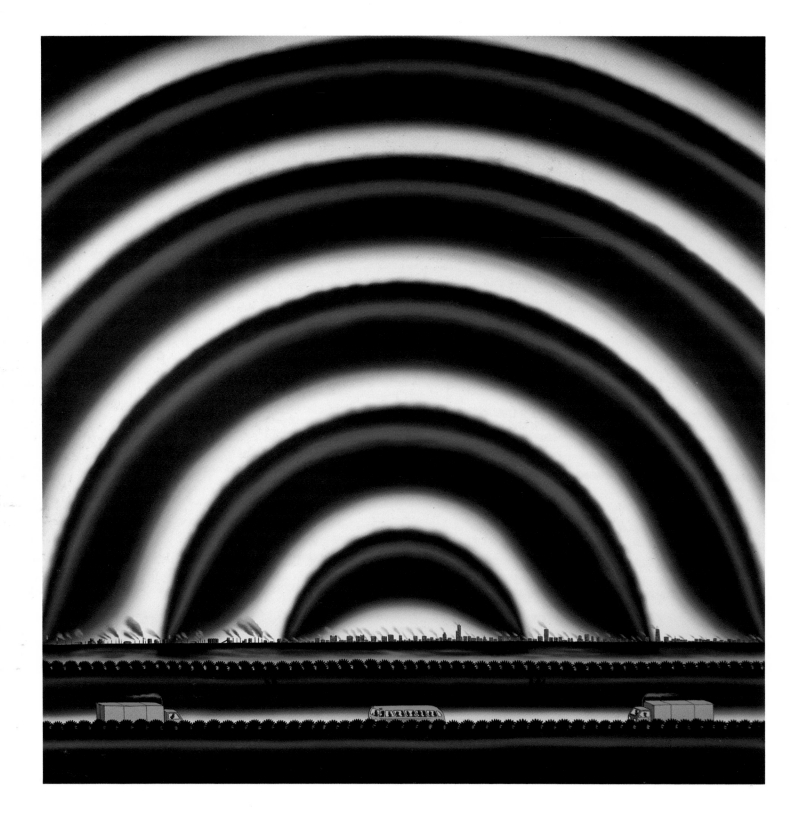

Roger Brown *Lake Effect.* 1980

Oil on canvas
72 x 72 in
Collection of the artist

Roger Brown

The Black Hills. 1984

Oil on canvas
48 x 72 in
Collection of William and Christine Robb

Roger Brown

Rain and Shine. 1979

Oil on canvas
60 x 84 in
Collection of Frits de Knegt

Roger Brown

Malibu. 1984

Oil on canvas
48 x 72 in
Collection of Daisy and Daniel Belin

Roger Brown

Hitchhiking in a Luminist Landscape. 1980

Oil on canvas
36 x 24 in
Collection of Dr. and Mrs. Richard D. Burns

Roger Brown

Who Killed David Warner? 1984

Oil on canvas
48 x 32 in
Private Collection

Roger Brown

Walkmans and Ghetto Blasters. 1984

Oil on canvas
52 x 72 in
Collection of Irving B. and Joan W. Harris

Roger Brown

Modern, Post-Modern. 1982

Oil on canvas
72 x 48 in
Collection of Jean and Dennis Albano

Selected Bibliography

Artists in this Exhibition

Martha Alf. Exhibition catalogue, essay by Suzanne Muchnic. Los Angeles: Fellows of Contemporary Art, Los Angeles, and Los Angeles Municipal Art Gallery, 1984.

Roger Brown. Exhibition catalogue, essay by Mitchell Douglas Kahan, contributions by Dennis Adrian and Russell Bowman. Montgomery: Montgomery Museum of Fine Arts, 1980.

April Gornik, in *Paradise Lost/Paradise Regained: American Visions of the New Decade, American Pavilion, 41st Venice Biennial.* Exhibition catalogue, essay by Marcia Tucker. United States Information Agency, 1984. pp. 106-07.

Alfred Leslie. Exhibition catalogue, essay by Robert Rosenblum. Boston: Museum of Fine Arts, 1976.

Alfred Leslie, in Frank H. Goodyear, Jr. *Contemporary American Realism Since 1960.* Boston: New York Graphic Society for Pennsylvania Academy of the Fine Arts, 1981. p. 240.

Norman Lundin: Works on Paper. Exhibition catalogue, essays by Alvin Martin and Patricia Failing. Seattle: Francine Seders Gallery, 1983.

Ed Paschke: Selected Works, 1967-1981. Exhibition catalogue, essays by Dennis Adrian, Linda L. Cathcart, Holliday T. Day and Richard Flood. Chicago: The Renaissance Society of the University of Chicago, 1982.

Contemporary American Luminism

Burton, Scott. "Generation of Light 1945-1969." In *Light: From Aten to Laser,* edited by Thomas B. Hess and John Ashbery. Art News Annual no. 35. New York: Newsweek, 1969.

DeAk, Edit, and Ingrid Sischy. "A Light Opportunity: An Editorial." *Artforum* 23, no. 5 (January 1985), p. 48.

Frank, Peter. "Light: Different Angles on the Landscape." *Arts Magazine* 58, no. 10 (June 1984), p. 19.

Focus on Light. Exhibition catalogue, essay by Lucy Lippard. Trenton: The New Jersey State Museum, 1967.

McShine, Kynaston, ed.*The Natural Paradise: Painting in America, 1800-1950.* Exhibition catalogue, contributions by Barbara Novak, Robert Rosenblum, John Wilmerding and Kynaston McShine. New York: Museum of Modern Art, 1976.

Perreault, John. "Literal Light." In *Light: From Aten to Laser,* edited by Thomas B. Hess and John Ashbery. Art News Annual no. 35. New York: Newsweek, 1969.

Rosenblum, Robert. *Modern Painting and the Northern Romantic Tradition: Friedrich to Rothko.* New York: Harper & Row, 1975.

Sharp, Willoughby. "Luminism and Kineticism." In *Minimal Art: A Critical Anthology,* edited by Gregory Battock. New York: E. P. Dutton, 1968.

19th-Century American Luminism

American Luminism. Exhibition catalogue, essay by William H. Gerdts. New York: Coe Kerr Gallery, 1978.

Baur, John I. H. "American Luminism, A Neglected Aspect of the Realist Movement in Nineteenth-Century American Painting." *Perspectives USA* 9 (Autumn 1954), pp. 90-98.

Novak, Barbara. *American Painting of the Nineteenth Century: Realism, Idealism, and the American Experience.* New York: Harper & Row, 1969.

Wilmerding, John, et. al. *American Light: The Luminist Movement, 1850-1870; Paintings, Drawings, Photographs.* Washington: National Gallery of Art with Harper & Row, 1980.

Detail of

Ed Paschke

Tres Lindos. 1982

Oil on canvas
42 x 80 in

Collection of Arthur and Carol Goldberg

Checklist of the Exhibition

Boldface numerals indicate color illustrations.

Martha Alf

Persimmons No. 2. 1978 p. 45
Pencil on bond paper
12 x 18 in (30.5 x 45.7 cm)
Private Collection

Persimmons No. 3. 1978 p. 44
Pencil on bond paper
12 x 18 in (30.5 x 45.7 cm)
Collection of O'Melveny and Myers

Tomato No. 2. 1978
Pencil on bond paper
12 x 18 in (30.5 x 45.7 cm)
Collection of O'Melveny and Myers

Pear Series II, No. 8. 1979
Pencil on bond paper
12 x 18 in (30.5 x 45.7 cm)
Private Collection

Apple No. 7. 1980 p. 48
Pencil on bond paper
11 x 14 in (28.0 x 35.6 cm)
Collection of the artist

Three Apples. 1980 p. 41
Pencil on bond paper
12 x 18 in (30.5 x 45.7 cm)
Collection of Frank M. Finck, M.D.

Pear No. 13. 1981 **p. 47**
Pastel pencil on bond paper
11 x 14 in (28.0 x 35.6 cm)
Collection of R.K. Benites

Pear No. 19. 1981
Pastel pencil on bond paper
11 x 14 in (28.0 x 35.6 cm)
Collection of Susan Leigh

Detail of
Roger Brown
Rain and Shine. 1979
Oil on canvas
60 x 84 in
Collection of Frits de Knegt

Apple No. 9. 1982
Pastel pencil on bond paper
11 x 14 in (28.0 x 35.6 cm)
Courtesy of the artist and Newspace Gallery,
Los Angeles

Pear No. 1 (for Andy Wilf). 1982 **p. 18**
Pastel pencil on bond paper
12 x 18 in (28.0 x 35.6 cm)
Collection of Mr. and Mrs. Barry Sanders

Pear No. 4. 1982
Prismacolor pencil on bond paper
11 x 14 in (28.0 x 35.6 cm)
Courtesy of the artist and Newspace Gallery,
Los Angeles

Pear No. 6. 1982 **p. 46**
Pastel pencil on paper
12 x 18 in (30.5 x 45.7 cm)
Courtesy of the artist and Newspace Gallery,
Los Angeles

Three Pears. 1982
Pastel pencil on paper
12 x 18 in (30.5 x 45.7 cm)
Courtesy of the artist and John Berggruen,
Gallery, San Francisco

Two Pears No. 3 (for Michael Blankfort).
1982 **p. 42**
Pastel pencil on paper
12 x 18 in (30.5 x 45.7 cm)
Collection of Alan S. Hergott

Objects on a Windowsill No. 1.
1982-83 p. 17
Prismacolor pencil on bond paper
11 x 14 in (28.0 x 35.6 cm)
Courtesy of the artist and Newspace Gallery,
Los Angeles

Three Apples. 1982-83
Prismacolor pencil on bond paper
11 x 14 in (28.0 x 35.6 cm)
Collection of Joni and Monte Gordon

Objects on a Windowsill No. 2. 1983
Prismacolor pencil on bond paper
11 x 14 in (28.0 x 35.6 cm)
Courtesy of the artist and Newspace Gallery,
Los Angeles

Pear No. 20. 1983 p. 46
Pastel pencil on paper
12 x 18 in (30.5 x 45.7 cm)
Courtesy of the artist and Newspace Gallery,
Los Angeles

Two Pears No. 6. 1983 **p. 43**
Pastel pencil on bond paper
12 x 18 in (30.5 x 45.7 cm)
Courtesy of the artist and Newspace Gallery,
Los Angeles

Three Apples. 1984
Pastel pencil on bristol vellum paper
14 x 22 in (35.6 x 55.9 cm)
Courtesy of the artist and Newspace Gallery,
Los Angeles

Three Crabapples. 1984 **p. 49**
Pastel pencil on bristol vellum paper
14 x 22 in (35.6 x 55.9 cm)
Courtesy of the artist and Newspace Gallery,
Los Angeles

Objects on a Windowsill No. 3.
1983-85
Prismacolor pencil on bond paper
11 x 14 in (28.0 x 35.6 cm)
Courtesy of the artist and Newspace Gallery,
Los Angeles

Roger Brown

Big Sky. 1979 **p. 23**
Oil on canvas
72 x 72 in (182.9 x 182.9 cm)
Collection of Mr. and Mrs. Edward Byron Smith, Jr.

Rain and Shine. 1979 **p. 72**
Oil on canvas
60 x 84 in (152.4 x 213.4 cm)
Collection of Frits de Knegt

Hitchhiking in a Luminist Landscape.
1980 **p. 74**
Oil on canvas
36 x 24 in (91.4 x 61.0 cm)
Collection of Richard D. and Jane Burns

Lake Effect. 1980 **p. 70**
Oil on canvas
72 x 72 in (182.9 x 182.9 cm)
Collection of the artist

Modern, Post-Modern. 1982 **p. 77**
Oil on canvas
72 x 48 in (182.9 x 121.9 cm)
Collection of Jean and Dennis Albano

Streetlight. 1983 **p. 69**
Oil on canvas
48 x 72 in (121.9 x 182.9 cm)
Collection of Gregory and Lourine Clark

The Black Hills. 1984 **p. 71**
Oil on canvas
48 x 72 in (121.9 x 182.9 cm)
Collection of William and Christine Robb

Malibu. 1984 **p. 73**
Oil on canvas
48 x 72 in (121.9 x 182.9 cm)
Collection of Daisy and Daniel Belin

Walkmans and Ghetto Blasters.
1984 **p. 76**
Oil on canvas
52 x 72 in (132.0 x 182.9 cm)
Collection of Irving B. and Joan W. Harris

Who Killed David Warner? 1984 **p. 75**
Oil on canvas
48 x 32 in (121.9 x 81.3 cm)
Private Collection

April Gornik

Cloud Wall. 1983 **p. 38**
Oil on canvas
84 x 90 in (213.4 x 228.6 cm)
Collection of Helen R. Runnells

Divided Sky. 1983 p. 37
Oil on canvas
72 x 85 in (182.9 x 215.9 cm)
Archer M. Huntington Art Gallery, University of Texas
at Austin, Gift of Mr. and Mrs. Jack Herring, 1984

Equator. 1983 p. 20, **39**
Oil on canvas
74 x 116 in (188.0 x 294.6 cm)
Collection of Laura Carpenter

Two Fires. 1983 **p. 14**
Oil on canvas
74 x 96 in (188.0 x 243.8 cm)
Private Collection

Corridor. 1984 p. 35
Oil on canvas
74 x 95 in (188.0 x 241.3 cm)
Collection of Frederick and Jan Mayer

Storm Center. 1984 p. 36
Oil on canvas
66 x 120 in (167.6 x 304.8 cm)
Collection of Laura Carpenter

Alfred Leslie

Approaching the Grand Canyon.
1977-81 p. 25
Watercolor on paper
18 x 24 in (45.6 x 61.0 cm)
Courtesy of the artist and Oil & Steel Gallery,
New York

Approaching the Grand Canyon. 1977-81
Watercolor on paper
18 x 24 in (45.6 x 61.0 cm)
Courtesy of the artist and Oil & Steel Gallery,
New York

Approaching the Grand Canyon. 1977-81
Watercolor on paper
18 x 24 in (45.6 x 61.0 cm)
Courtesy of the artist and Oil & Steel Gallery,
New York

**Drive-In Movie, Santa Barbara,
California.** 1977-81
Watercolor on paper
30 x 42 in (76.2 x 106.7 cm)
Courtesy of the artist and Oil & Steel Gallery,
New York

**Drive-In Movie, Santa Barbara,
California.** 1977-81 p. 32
Watercolor on paper
18 x 24 in (45.7 x 61.0 cm)
Courtesy of the artist and Oil & Steel Gallery,
New York

**Drive-In Movie, Santa Barbara,
California.** 1977-81 p. 32
Watercolor on paper
18 x 24 in (45.7 x 61.0 cm)
Courtesy of the artist and Oil & Steel Gallery,
New York

**Full Moon and Rising Sun Near Tulsa,
Oklahoma.** 1977-81
Watercolor on paper
18 x 24 in (45.7 x 61.0 cm)
Collection of Richard Bellamy

Heading for Gallup, New Mexico.
1977-81 p. 16
Watercolor on paper
18 x 24 in (45.7 x 61.0 cm)
Courtesy of the artist and Oil & Steel Gallery,
New York

Heading for Gallup, New Mexico. 1977-81
Watercolor on paper
18 x 24 in (45.7 x 61.0 cm)
Courtesy of the artist and Oil & Steel Gallery,
New York

Heading for Gallup, New Mexico.
1977-81 p. 16
Watercolor on paper
18 x 24 in (45.7 x 61.0 cm)
Courtesy of the artist and Oil & Steel Gallery,
New York

Near Winslow, Arizona. 1977-81
Watercolor on paper
18 x 24 in (45.7 x 61.0 cm)
Courtesy of the artist and Oil & Steel Gallery,
New York

Near Winslow, Arizona. 1977-81
Watercolor on paper
18 x 24 in (45.7 x 61.0 cm)
Courtesy of the artist and Oil & Steel Gallery,
New York

Near Winslow, Arizona. 1977-81
Watercolor on paper
18 x 24 in (45.7 x 61.0 cm)
Courtesy of the artist and Oil & Steel Gallery,
New York

**Outside Blue Water Village,
New Mexico.** 1977-81
Watercolor on paper
18 x 24 in (45.7 x 61.0 cm)
Courtesy of the artist and Oil & Steel Gallery,
New York

**Outside Blue Water Village,
New Mexico.** 1977-81
Watercolor on paper
18 x 24 in (45.7 x 61.0 cm)
Courtesy of the artist and Oil & Steel Gallery,
New York

**Outside Blue Water Village,
New Mexico.** 1977-81
Watercolor on paper
18 x 24 in (45.7 x 61.0 cm)
Courtesy of the artist and Oil & Steel Gallery,
New York

Outside Laguna, New Mexico.
1977-81 p. 26
Watercolor on paper
30 x 42 in (76.2 x 106.7 cm)
Collection of Robin Wright Moll

Outside Laguna, New Mexico.
1977-81
Watercolor on paper
30 x 42 in (76.2 x 106.7 cm)
Courtesy of the artist and Oil & Steel Gallery,
New York

Outside Laguna, New Mexico. 1977-81
Watercolor on paper
30 x 42 in (76.2 x 106.7 cm)
Courtesy of the artist and Oil & Steel Gallery,
New York

The Painted Desert. 1977-81
Watercolor on paper
18 x 24 in (45.7 x 61.0 cm)
Collection of Jane Timkin

The Painted Desert. 1977-81 p. 27
Watercolor on paper
18 x 24 in (45.7 x 61.0 cm)
Collection of Jane Timkin

The Painted Desert. 1977-81 p. 27
Watercolor on paper
18 x 24 in (45.7 x 61.0 cm)
Collection of Jane Timkin

**Rocky Beach: Santa Barbara,
California.** 1977-81 p. 28
Watercolor on paper
40 x 60 in (101.6 x 152.4 cm)
Moderna Museet, Stockholm

**Rocky Beach: Santa Barbara,
California.** 1977-83 p. 28
Watercolor on paper
18 x 24 in (45.7 x 61.0 cm)
Courtesy of the artist and Oil & Steel Gallery,
New York

**Rocky Beach: Santa Barbara,
California.** 1977-83
Watercolor on paper
18 x 24 in (45.7 x 61.0 cm)
Courtesy of the artist and Oil & Steel Gallery,
New York

Bridge from Mill Creek Park, Youngstown, Ohio. 1983
Watercolor on paper
18 x 24 in (45.7 x 61.0 cm)
Collection of Mr. and Mrs. Bagley Wright

Bridge from Mill Creek Park, Youngstown, Ohio. 1983 p. 30
Watercolor on paper
18 x 24 in (45.7 x 61.0 cm)
Collection of Mr. and Mrs. Bagley Wright

Bridge from Mill Creek Park, Youngstown, Ohio. 1983 p. 31
Watercolor on paper
18 x 24 in (45.7 x 61.0 cm)
Collection of Mr. and Mrs. Bagley Wright

Entering 91 at Holyoke, Massachusetts. 1983 p. 33
Watercolor on paper
18 x 24 in (45.7 x 61.0 cm)
Courtesy of the artist and Oil & Steel Gallery, New York

Rainbow near Hadley, Massachusetts. 1983
Watercolor on paper
18 x 24 in (45.7 x 61.0 cm)
Courtesy of the artist and Oil & Steel Gallery, New York

Rainbow near Hadley, Massachusetts. 1983
Watercolor on paper
18 x 24 in (45.7 x 61.0 cm)
Courtesy of the artist and Oil & Steel Gallery, New York

Rainbow near Hadley, Massachusetts. 1983
Watercolor on paper
18 x 24 in (45.7 x 61.0 cm)
Courtesy of the artist and Oil & Steel Gallery, New York

Turn-off, Holyoke, Massachusetts. 1983
Watercolor on paper
40 x 60 in (101.6 x 152.4 cm)
Courtesy of the artist and Oil & Steel Gallery, New York

Norman Lundin

San Antonio Anatomy Lesson. 1982 p. 54
Pastel and charcoal on paper
28 x 44 in (71.1 x 111.8 cm)
Courtesy of the artist and Space Gallery, Los Angeles

Orange Tablecloth and a Blackboard. 1983 p. 19
Pastel on paper
28 x 44 in (71.1 x 111.8 cm)
Private Collection

60th St. Studio: White Tablecloth. 1983 p. 58
Pastel on paper
28 x 44 in (71.1 x 111.8 cm)
Courtesy of the artist and Francine Seders Gallery, Seattle

60th St. Studio: Wrapped Package. 1983 p. 59
Pastel on paper
27 x 43 in (68.6 x 109.2 cm)
Collection of Riddell, Williams, Bullit & Walkinshaw

Studio: Drawing of a Goat, No. 2. 1983 p. 55
Pastel on paper
28 x 44 in (71.1 x 111.8 cm)
Collection of Karl K. Ichida

60th St. Studio: About 8:00 AM (Large Version). 1984
Pastel on paper
28 x 44 in (71.1 x 111.8 cm)
Courtesy of the artist and Space Gallery, Los Angeles

60th St. Studio: Drafting Stool. 1984 p. 51
Pastel on paper
44 x 28 in (111.8 x 71.1 cm)
Courtesy of the artist and Allport Associates Gallery, San Francisco

60th St. Studio: South Loading Dock. 1984 p. 56
Pastel on paper
28 x 44 in (71.1 x 111.8 cm)
Corson/Davis Collection

Studio Blackboard. 1984 p. 52
Pastel on paper
28 x 44 in (71.1 x 111.8 cm)
Collection of The Southland Corporation, Dallas

Studio: Two Drawings and a Red Stool. 1984 p. 53
Pastel on paper
28 x 44 in (71.1 x 111.8 cm)
Collection of Dr. Alvin Martin

Sunset Hotel No. 1. 1984-85 p. 21
Pastel on paper
44 x 28 in (111.8 x 71.1 cm)
Courtesy of the artist and Francine Seders Gallery, Seattle

Sunset Hotel No. 2. 1984-85 p. 57
Pastel on paper
28 x 44 in (71.1 x 111.8 cm)
Courtesy of the artist and Francine Seders Gallery, Seattle

Ed Paschke

Montaigne. 1979 p. 62
Oil on canvas
36 x 102 in (91.4 x 259.1 cm)
Collection of Mr. and Mrs. Lawrence I. Aronson

Critique. 1981 p. 63
Oil on canvas
42 x 70 in (106.7 x 177.8 cm)
Collection of Ed and Nancy Paschke

Tres Artistique. 1981 p. 61
Oil on canvas
19 ¾ x 42 in (50.2 x 106.7 cm)
Collection of Mr. and Mrs. Alexander C. Speyer III

Elektroid. 1982 p. 66
Oil on canvas
36 x 82 in (91.4 x 208.3 cm)
Stephen S. Alpert Family Trust

Embrasse. 1982 p. 65
Oil on canvas
42 x 80 in (106.7 x 203.2 cm)
Private Collection

Pachuco. 1982 p. 67
Oil on canvas
42¼ x 82 in (107.3 x 208.3 cm)
Private Collection

Tres Lindos. 1982 p. 22
Oil on canvas
42 x 80 in (106.7 x 203.2 cm)
Collection of Arthur and Carol Goldberg

Waxworks. 1982 p. 64
Oil on canvas
32 x 82 in (81.3 x 208.3 cm)
Collection of Continental Illinois National Bank and Trust Company of Chicago

Photograph Credits

Edward Alf, 40
William H. Bengtson, 22, 23, 62, 63, 64, 65, 66, 67, 69, 70, 71, 73, 74, 75, 76, 77
Chris Eden, 19, 21, 51, 53, 54, 55, 57, 58, 59
Joe Freeman, 50
Susan and Richard Golomb Photographers, 61
Roy Gumpel, 24
George Holmes, 37
Dennis Keeley, 18, 42, 46
Jeannette Montgomery, 34
Nic Nicosia, 52, 56
Douglas M. Parker, 17, 41, 43, 44, 45, 46, 47, 48, 49
Pelka/Noble, 36
Stephen Petegorsky, 16, 25, 27, 28, 29, 30, 31, 32, 33
Jeff Rosenbaum, 72
Steven Sloman Fine Arts Photography, 16, 26, 27
David Wagenaar, 60, 68
Zindman/Fremont, 14, 20, 35, 36, 38, 39

Type set in Helvetica by Thomas & Kennedy, Seattle, Washington. Separations, printing on 157 gsm Espel dull and binding by Nissha Printing Co., Ltd., Kyoto, Japan. Edition: 2,000